Traditional & Contempora

CHINESE BRUSH PAINTING

Using ink and water soluble media

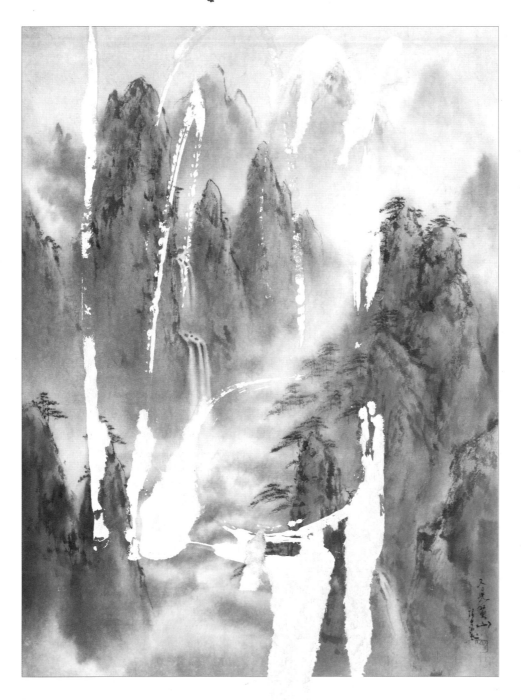

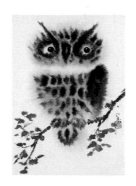

To my wife Angie, my children
William and May Ling, and to my
sister Cheng Wei and parents who
taught me to love and appreciate nature.

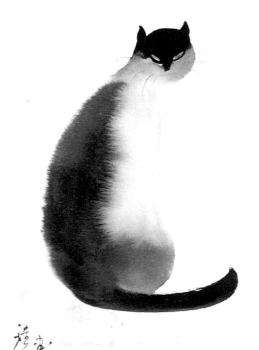

Traditional & Contemporary

CHINESE BRUSH PAINTING

Using ink and water-soluble media

CHENG YAN

SEARCH PRESS

First published in Great Britain 2005

Search Press Limited
Wellwood, North Farm Road,
Tunbridge Wells, Kent TN2 3DR

Text copyright © Cheng Yan 2005

Photographs throughout the book by Charlotte de la Bédoyère, Search Press Studios; photograph on page 22 by Roger Fickling.

Photographs and design copyright © Search Press Ltd. 2005

ISBN 1 903975 19 0

The Publishers and author can accept no responsibility for any consequences arising from the information, advice or instructions given in this publication.

Suppliers
If you have difficulty in obtaining any of the materials and equipment mentioned in this book, please visit the Search Press website for details of suppliers: www.searchpress.com

Alternatively, you can write to the Publishers at the address above, for a current list of stockists, which includes firms who operate a mail-order service.

Publishers' note

All the step-by-step photographs in this book feature the author, Cheng Yan, demonstrating his painting techniques. No models have been used.

There are references to animal hair brushes in this book. It is the publishers' custom to recommend synthetic materials as substitutes for animal products wherever possible. There is now a large range of brushes available made from artificial fibres, and they are satisfactory substitutes for those made from natural fibres.

Manufactured by Classicscan Pte, Ltd, Singapore

Printed in Malaysia by Times Offset (M) Sdn Bhd

I would like to give special thanks to my editor Roz Dace, without whose help I would not have completed this book. I would also like to thank John Dalton who kindly helped with the initial stages of editing, Lotti who patiently photographed my painting techniques, and Roger for taking the photograph on page 22.

Page 1
HUANG SHAN

Huang Shan, in the province of An Hui, is my favourite mountain and I go there as often as I can. Throughout history, this beautiful place has inspired many artists, poets and philosophers to create great works. I chose to paint the waterfall cascading into the valley mists on mulberry tree paper. The outlines, shadows and texture are brushed in using varying tones of black ink and earth colours, leaving white areas of the paper for the soft mist nestling between the craggy mountain sides.

Size of painting: 290 x 390mm (11³/₈ x 15³/₈in)

Page 2
OWL

A wet-into-wet technique is used to portray the owl feathers, which are painted on to a light brown wash with a medium soft brush and diluted ink. The eyes are added when the painting is dry, then the branch, which is painted with dry brush strokes. The autumn leaves add a harmonious colourful balance.

Size of painting: 125 x 180mm (5 x 7in)

Page 2
MING

Cats are my favourite subject. They are inspiring animals to paint with their fluid movements, relaxed poses and beautiful fur. Ming is my cat and in this painting her mood and spirit are portrayed with black ink and a few simple brush strokes on watercolour paper.

Page 3
LOTUS POND

The lotus symbolises purity and harmony. In this painting a single flower floats above two carp swimming harmoniously through clear water. A blue wash on Xuan paper is the background for the painting. The fish scales and flower petals are highlighted with white gouache.

Size of painting: 140 x 190mm (5¹/₂ x 7¹/₂ in)

Page 5
BAMBOO

This luxuriant evergreen plant survives the cold of winter, therefore it symbolises strength, energy and vitality. It is also associated with the virtues of modesty, nobility and gentleness. This painting includes all the brush stroke techniques shown in this book.

Size of painting: 340 x 130mm (13³/₈ x 5(13¹/₈ in)

CONTENTS

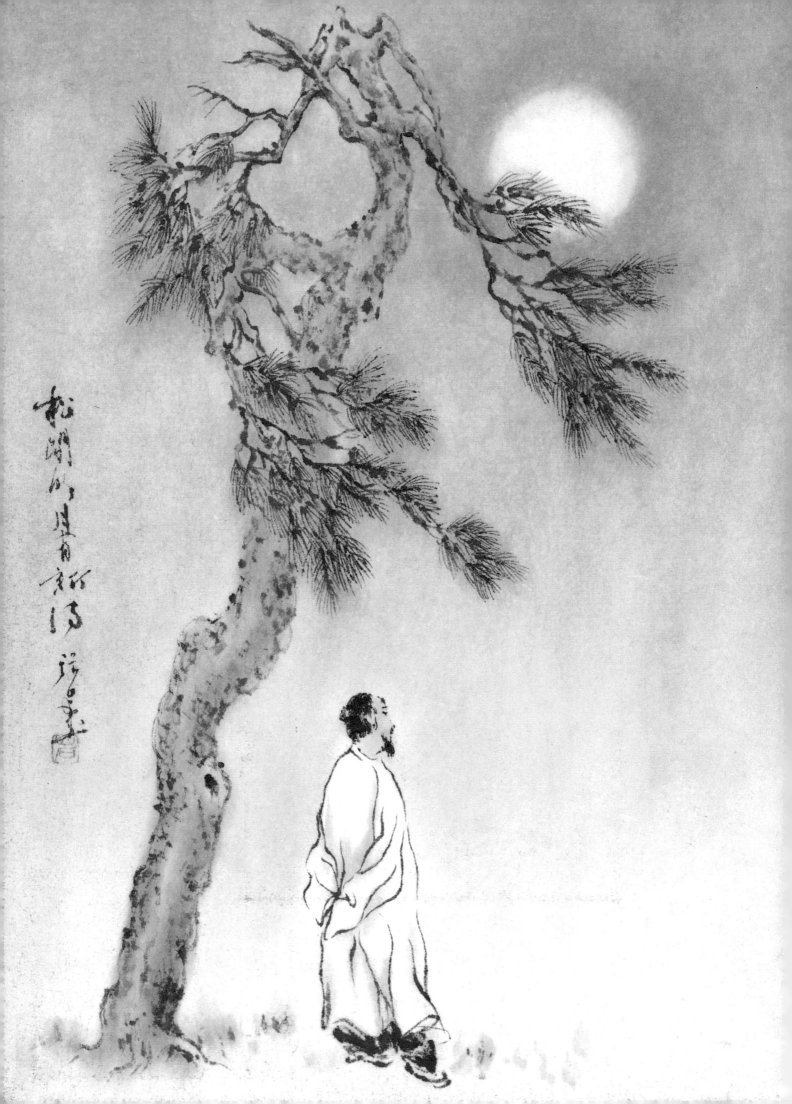

INTRODUCTION

The ancient and beautiful art of Chinese brush painting has a long and fascinating history. For over 3,000 years generations of Chinese artists have portrayed the spirit and essence of the natural world in a way that is as exquisite as it is inspirational. The techniques have evolved over the centuries and brush paintings are not merely beautiful, but reflect the innermost beliefs and philosophies of the artist. The skilful brushwork and delicate washes of colour create wonderful feelings of harmony, peace and tranquillity and it is this spiritual quality that makes Chinese brush painting so evocative.

You do not have to be an experienced artist to start Chinese brush painting, and this book has been written with that in mind. However, you do need to understand the basic principles and techniques to be able to give personal expression to your work. The brush strokes are simple, but it is how they are placed within the space that is important, and how you approach the painting. The serene quality of the images comes from the artist's understanding of the chosen subject. To capture the essence of a landscape, a bird or a flower, you must understand it before you begin. This is the way of the Chinese artist.

In this book I have briefly introduced the history and general principles of traditional Chinese painting. It is impossible to include a detailed account of how the styles and philosophies developed, so if you are inspired by my teaching , do spend some time studying other artists. Your brush and ink skills will improve greatly if you practise the methods shown here, and if you extend your knowledge and understanding of this rich and rewarding art form. I have based the book on traditional ideas and techniques, but have also included methods that I have developed myself which include the use of Western watercolour paper and water-based paints. In this way, our exploration of Chinese painting provides a link between ancient and modern, East and West. I do hope you enjoy it.

LISTENING TO THE PINE IN THE MOONLIGHT

This painting was inspired by a visit to Huang Shan in the Province of An Hui. I found a beautiful moonlit pine tree on the mountain side, and imagined myself as a poet one thousand years ago watching the same peaceful scene, wondering what words he would have written. The atmosphere of the scene was carried back to my studio where I captured the spirit of the moment. The pine tree and figure are brushed on to Xuan paper with black ink, then varying tones and texture are added. Watercolour is washed over the surface, leaving the white of the paper for the moon.

Size of painting: 240 x 345mm (9½ x 13½in)

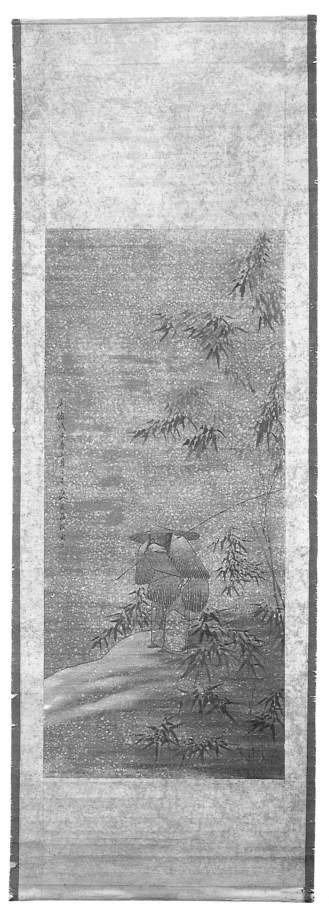

STYLES

There are three main styles in Chinese painting. The brush and ink techniques are similar for all of them, but they are very different in appearance:

Gongbi is detailed, and only a limited number of ink colours are used. Brush strokes are applied to the painting surface to capture small details such as feathers on a bird or petals on a flower.

Xieyi is free and spontaneous and again, only ink is used, but the colours are not limited. Nature is interpreted rather than copied and brush strokes suggest a form or a texture. Influenced by calligraphy and poetry, this style developed to include inscriptions which reflected the personal philosophies of the artists.

Half Gongbi, half Xieyi combines both of the above approaches. The union of detail and spontaneity can be used to great effect. A detailed foreground study against a more fluid background offers interesting, harmonious contrasts. A bird captured vividly on the page, with detailed feathering, set against a more abstract background is typical of this traditional style.

This traditional painting of a fisherman in the snow is half Gongbi and half Xieyi, so it combines a detailed with a free style. The loose background throws the figure and bamboo forward, enhancing the perspective. Paintings like these have been inspired by poetry and literature for thousands of years, with artists portraying their ideas, thoughts and emotions.
Size of painting: 62 x 180cm (24½ x 80in)

SUBJECTS

Chinese painting also has five subject categories:

Shan Shui – landscapes. These are mainly paintings of sky, mountains and water and if figures appear, they are not the dominant subject.

Ren Wu – figures. These are mainly paintings of people, although other subjects are often included in the pictures.

Qin Shou – animals, birds and insects. When painting these subjects, it is important for the artist to capture life and vitality in the image. The spirit and the movement of the animal, bird or insect is an integral part of the painting.

Hua Hui – flowers. The emphasis is on capturing the essence of the subject, whether it is flowers or blossom on a tree.

Hua Niao – flowers and birds. The combination of these subjects was popular early on in the history of brush painting. The tradition continues today, with the same approaches and philosophies that have survived over generations of artists.

PEONIES

The subject category of this painting is Hua Hui. Before painting, I studied the flower so that I could capture its essence and beauty. The painting techniques are shown in the demonstration which starts on page 40.

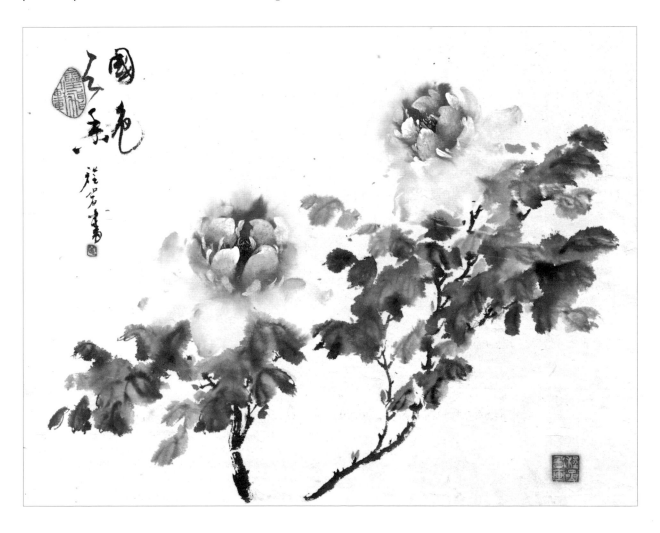

MATERIALS &
GETTING STARTED

The main materials used for Chinese brush painting and calligraphy have been the same for thousands of years and they are known as the 'Four Treasures of Study'. Using the traditional combination of brush, ink, inkstone and paper is as important to the artist as the meditations and philosophies which accompany each painting. Other materials are also needed and they are all shown in this section. They can be found in most art suppliers.

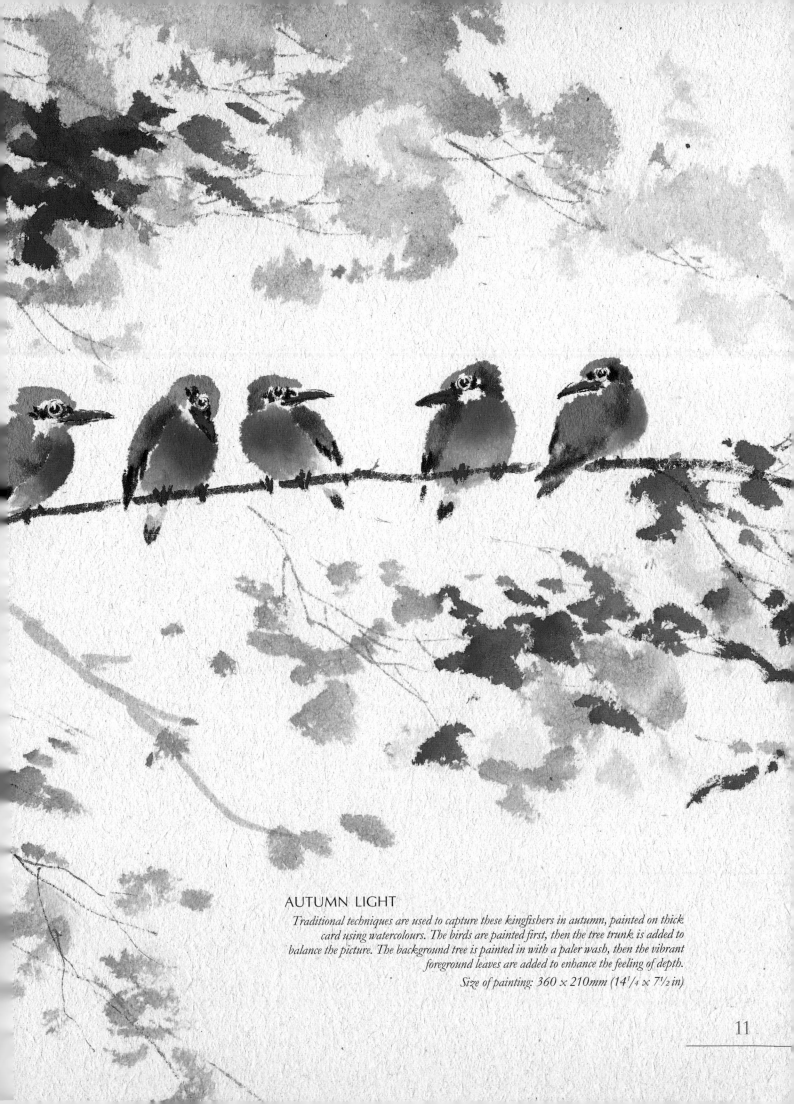

AUTUMN LIGHT

Traditional techniques are used to capture these kingfishers in autumn, painted on thick card using watercolours. The birds are painted first, then the tree trunk is added to balance the picture. The background tree is painted in with a paler wash, then the vibrant foreground leaves are added to enhance the feeling of depth.

Size of painting: 360 x 210mm (14¹/₄ x 7¹/₂ in)

BRUSHES

The brush is the First Treasure and it is the tool through which all thoughts and philosophies are expressed.

The Chinese brush is wonderfully versatile and is available in different sizes: small, medium and large. It can be used for the smallest details or for free, spontaneous, larger strokes. This versatility is due to its sensitivity and flexibility. It can be used to create smooth, fluid lines without effort.

Chinese brushes are generally classified into three types according to the different qualities of the animal hair used by the manufacturer: soft, stiff and mixed. The brush is recognised as the artist's First Treasure, through which all thoughts and philosophies are expressed.

Soft brush

Yang Hao This is made from goat hair or synthetic fibres and it is suitable for the freehand, spontaneous style of painting. The hairs are soft so they can absorb plenty of ink, water and paint, and the brush is ideal for washes, creating rich tones and for adding colour.

Stiff brush

Lang Hao This is made from badger, rabbit, horse, pig or deer hair and it is suitable for painting fine lines, or adding detail to a painting. The hairs are stiff and do not hold large amounts of ink, water or paint. If you want to paint outlines, hills, rocks or trees, this brush is the one to use.

Mixed brush

Jian Hao The third kind of brush contains a mixture of soft and stiff hair. The ratio may be 70 per cent rabbit hair and 30 per cent goat hair, or vice versa, or sometimes 50 per cent of each. These brushes are relatively easy to use and give strokes which have both strength and grace.

Ideally, you should have a selection of all three kinds in the different sizes. When buying your brushes, you should look for a well rounded tip with a fine point, and the bristles should spring back into shape during use.

Always soak a new brush in cold water before it is used to remove the sticky glue coating from the tip. The hair will then fluff out and be ready to use. Also, do not replace the brush in its plastic cover after use, but wash it in clean water and hang it up with the tip facing down, as shown opposite. Synthetic substitutes are also available, as well as brushes which can be used for specific special effects.

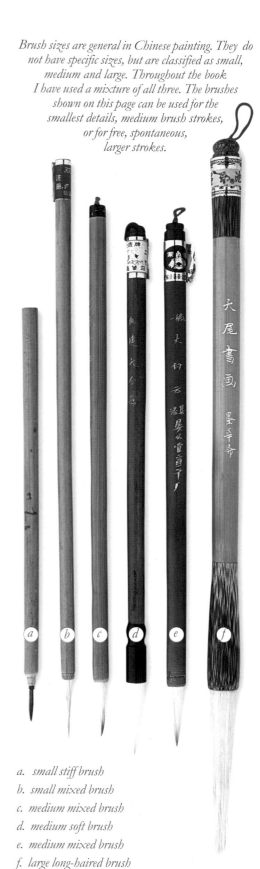

Brush sizes are general in Chinese painting. They do not have specific sizes, but are classified as small, medium and large. Throughout the book I have used a mixture of all three. The brushes shown on this page can be used for the smallest details, medium brush strokes, or for free, spontaneous, larger strokes.

a. *small stiff brush*
b. *small mixed brush*
c. *medium mixed brush*
d. *medium soft brush*
e. *medium mixed brush*
f. *large long-haired brush*

Water pots

You will need two water pots. One with clean water to wet your brushes before you load the ink and colour, the other to clean your brushes while painting.

Brush holder

This is a Chinese brush holder or *Bijia*. Brush handles are traditionally made of bamboo or wood, although they can be made of other materials. A loop is normally attached to the blunt end. When you have finished painting, your clean, wet brush should be hung up, as shown below. This helps to retain the shape of the tip. It is important to do this because you will not be able to achieve smooth, fluid lines if the brush loses its roundness and flexibility.

When in use, the brushes can be placed on beautifully painted ceramic supports. Dry brushes can be stored in wood, bamboo or ceramic cases. These are often beautifully carved and decorated, like the brush holders.

Water pots are an essential part of your equipment. I use two of these – one contains clean water, the other is used to clean brushes between ink and colour applications.

Dry brushes can be stored in a jar, but make sure they are thoroughly dry before removing them from the hanger.

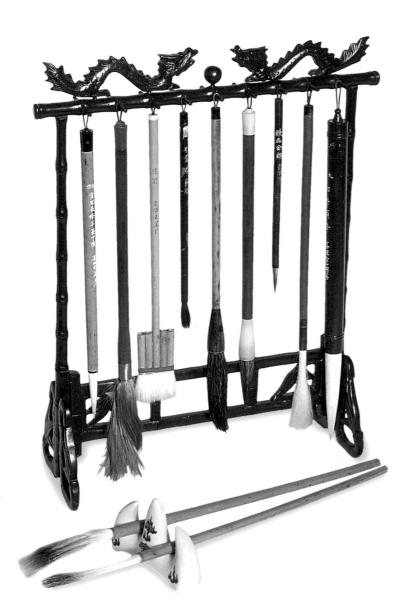

BRUSH HANGER AND SUPPORT

These traditional hangers are the best way to keep your brushes in good condition. After use, clean the brushes thoroughly, then hang them up. This will prevent any water trickling down into the handles. This is particularly important if the handles are made of bamboo because water can weaken the brush. The ceramic supports are used as a resting place for brushes that are not being used while you are painting. Several brushes are often used if a painting contains different colours.

INK

Ink and inkstones, the Second and Fourth Treasures, convey your ideas and thoughts on to the paper.

Traditional Chinese ink *mo,* is a simple, yet highly effective medium for painting and writing. It does not fade when exposed to sunlight and once dried, an ink mark will not dissolve when it meets with water. Many ink paintings and pieces of ancient calligraphy have survived for thousands of years in perfect condition.

Ink is recognised as the second Treasure because it would be impossible for artists to paint without it. Ink can be used in many different ways, from creating washes to drawing thin lines. This allows the artist to capture the essence of any subject, whether it is an atmospheric landscape or a bird painted in the detailed style.

Chinese ink is made by rubbing an ink stick round and round on an ink stone. If you make too much, any excess can be kept in an airtight container for future use. The recipe for making ink sticks has not changed over the centuries. Soot and glue are mixed together and then moulded into solid sticks of different shapes.

There are two main types of ink stick: oil smoke and pine smoke. Oil smoke ink dries very black, has a glazed finish and is good for painting. It can be used for most techniques. Pine smoke ink dries a lighter colour and has a matt finish. It is often used for fine detail, exquisite brushwork and calligraphy.

Recently, ready-prepared tubes and bottles of ink have become available. These are now extremely popular with artists because they are convenient to use and easy to carry around. However, it is better to use the traditional method because the whole ink grinding process is an important part of the painting ritual. Slowly turning the ink stick on the stone eases the artist into a contemplative mood. Infused with calmness and serenity, the artist has time to consider the subject and the painting.

Ink stones

Choosing a good ink stone is important. The best known are *Duan* ink stones which are carved from rocks quarried in Duanxi, South China, and *She* ink stones from Shexian County. Both are hard stones with a fine grain and they are carved flat with shallow reservoirs in the centre where the ink sticks are ground. They are usually decorated, either with carvings or calligraphy. A proverb or beautiful image carved into an ink stone can be very inspiring. Miniature landscapes, symbolic objects, figures, historical events or fantastic beasts are often featured. The finest stones are works of art in their own right and extremely valuable. The ink stone is recognised as the Fourth Treasure because it is the resting place of the ink and without it the artist could not create beautiful paintings.

INK BOXES

Shown here is a bottle of liquid ink (top left), and a selection of ink sticks, some of which are resting on a carved ink stone. The sticks and stone are normally encased in decorative wooden boxes. The ink stone box lid is usually lined with a cotton or silk pad which absorbs any excess ink after grinding.

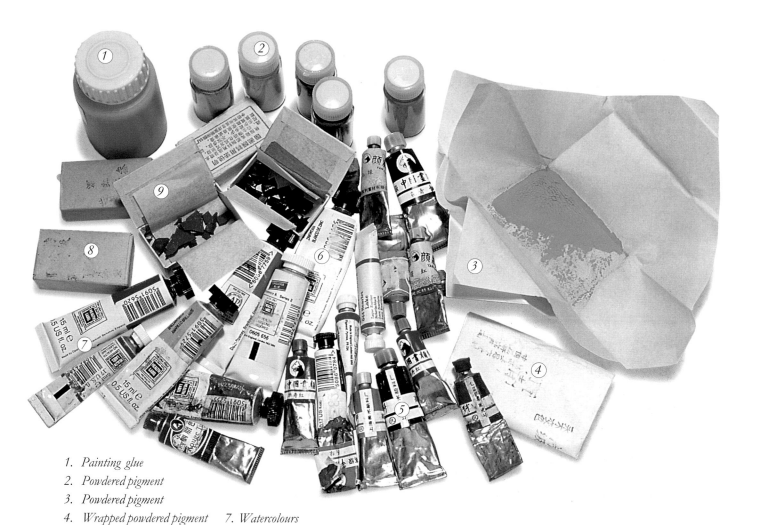

1. Painting glue
2. Powdered pigment
3. Powdered pigment
4. Wrapped powdered pigment
5. Chinese watercolours
6. Gouache
7. Watercolours
8. Box for pigment chips
9. Pigment chips

Colours

There are two kinds of colour in Chinese painting. One is mineral pigment and the other is plant pigment. They are available in both powder and solid chip form. Generally, mineral colours give an opaque finish with good coverage and plant pigments are more transparent. Professional artists favour the traditional method of making colours by mixing the pigment or chips with water and painting glue, but this requires great skill. Too much glue makes the colours dull and the brush sticky, too little glue and the colour will not adhere to the paper.

I prefer to use the traditional colours most of the time, but occasionally, I use modern Chinese tube paints. They resemble watercolours and are much easier to use. I have used them in this book because they are ideal for beginners, and they are just as effective as traditional colours.

Although ink is the traditional painting medium, I also love experimenting with watercolour and gouache. Wonderful wash effects can be achieved with watercolours when they are used in the traditional Chinese style. I use tube paints and love the vibrancy and translucency of the colours. Gouache is a water-based opaque medium, also available in tubes. I use this frequently for highlighting small and large areas.

PAPER

Paper is the Third Treasure and it is the medium for expressing all ideas and thoughts.

Chinese artists have painted and used calligraphy on paper and silk for centuries, although paper is favoured. There are many different types available nowadays which have been specially made for Chinese painting.

Xuan paper is the most commonly used because of its strength and absorbency. It is named after Xuancheng in the Anhui province of China, a town famous for making and distributing paper. Xuan paper, which is soft and white, is made from tree bark and rice straw and in Western countries it is known as rice paper. There are three types: raw, sized and half-sized.

I mainly use raw paper. It absorbs ink quickly and is therefore ideal for freestyle painting. Sized paper is not absorbent and is suitable for painting a more detailed style. Half-sized paper is semi-absorbent, so a combination of soft and hard lines, varying tones and detail is possible.

Of course, all kinds of interesting papers can be used, including tree bark, grass and silk paper. Most are available in a variety of colours, textures, sheet sizes and thicknesses. I have used Xuan paper, watercolour paper and Mulberry (tree bark) paper in this book, so if you follow all the demonstrations you will soon see how the different papers react to the inks and water-based media. I prefer to use textured watercolour paper, so choose to use rough 300gsm (140lb). This is a good weight of paper and it produces some wonderful effects when used with the Chinese watercolours.

I would recommend that beginners practise their painting skills on lots of different papers so that they become familiar with the qualities and characteristics of each type. Some of you may prefer the spontaneous style, others may want to paint in a more detailed way. Whatever you decide, you will only learn which is the best for you by practising as much as you can.

a. *Sized Xuan paper*

b. *Lightweight Mulberry paper*

c. *Coloured raw Xuan paper*

d. *Heavyweight Mulberry paper*

e. *Tinted Xuan paper with gold flakes*

f. *Half-sized Xuan paper*

g. *Sized Xuan paper*

h. *Japanese machine-made paper*

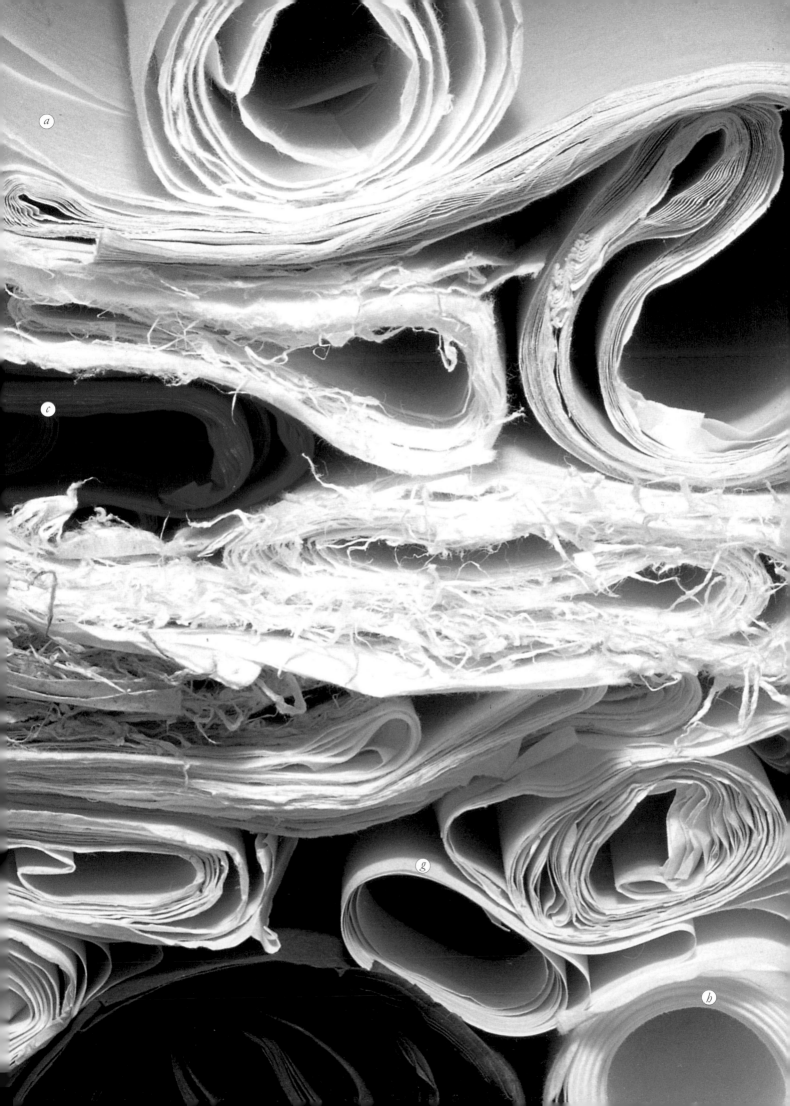

SEALS

*The perfect combination of seal, ink and calligraphy
has been used for centuries.*

Seals, also known as chops, are hand-engraved and they have
been used for centuries in Chinese painting. Originally,
official documents were authorised with seals and the
stamped characters were highly respected. They were also
used as a sign of ownership.

In Chinese art, seals are combined harmoniously with ink
and calligraphy to create a perfectly balanced picture. The
engraved characters can be formed into short poems or
quotes, and they can be symbolic. Normally made of stone,
and beautifully carved, they are used like painting blocks.

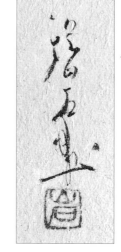

*This is the
traditional way to
finish a painting,
with the artist's
signature and
name. This is my
seal, written in
calligraphic style
with a small
Chinese brush,
and it represents
my name.*

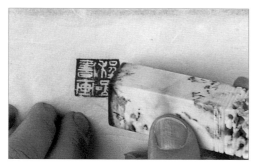

*The characters are pressed into red ink paste and
then stamped carefully on to the finished painting.*

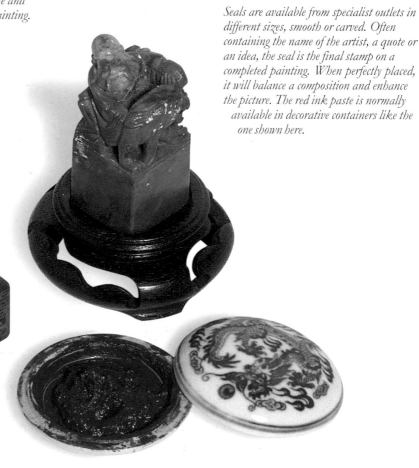

*Seals are available from specialist outlets in
different sizes, smooth or carved. Often
containing the name of the artist, a quote or
an idea, the seal is the final stamp on a
completed painting. When perfectly placed,
it will balance a composition and enhance
the picture. The red ink paste is normally
available in decorative containers like the
one shown here.*

MY SEALS

The carvings on seals are artworks in themselves. They can be carved in two ways:
yin the inscription appears as white over red; *yang* the inscription appears as red over white. I often use these three seals:

 My name seal Cheng Yan. Yin carving.

 The painting and calligraphy of Cheng Yan. Yang carving.

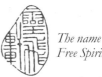 *The name of my studio Free Spirit Studio*

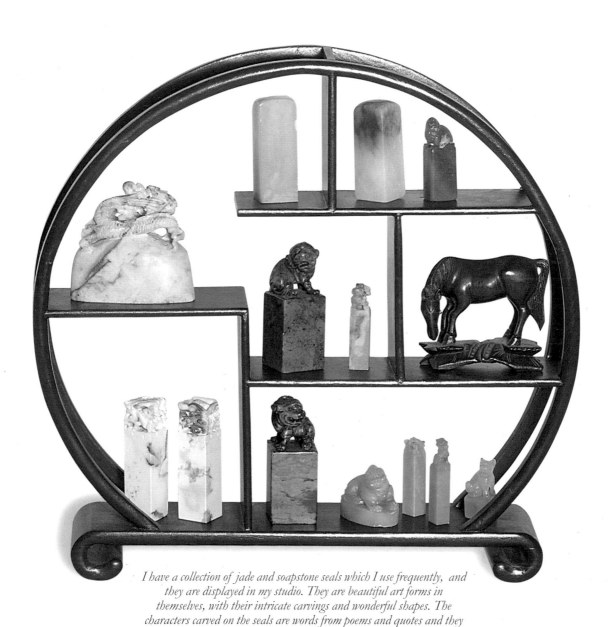

I have a collection of jade and soapstone seals which I use frequently, and they are displayed in my studio. They are beautiful art forms in themselves, with their intricate carvings and wonderful shapes. The characters carved on the seals are words from poems and quotes and they also represent my studio name.

OTHER EQUIPMENT

You will also need the items on this page if you want to paint successful pictures. I have included mannequins because it is important to study your subjects and to practise your painting whenever you can.

Paperweights

A pair of paperweights is needed to hold down the paper when you are painting. Many traditional paperweights are highly decorative, sometimes with carved Chinese proverbs engraved into their surfaces. It adds to the sense of tradition when you are painting and they are also extremely useful. Often Chinese papers do not lie flat and painting is made easier if paperweights are used.

Mannequins

You should always study subjects from life because it is important to capture the spirit and essence of whatever you are painting. It is only through observation that you will learn how to develop your own style. Mannequins are a useful substitute because they enable you to study complex structures easily.

Felt

Because the paper used in Chinese painting is very absorbent, and wet paper will stick to a table or any hard working surface, it is advisable to lay a thick felt mat under the paper. Special felt mats are available, but a piece of blanket could be used instead. Do not use absorbent paper as a substitute, as some of the colour will seep out of your painting into the background paper.

Alum water

I sometimes use alum water, during or after painting to prevent my colours running when the paper is wet. Put a teaspoon of alum crystals into a jar of clean water, and it will gradually dissolve. It is then ready to use. The proportion of alum to water is crucial. Too much alum and the paper will be fragile and the solution will make your colours appear dull. If there is not enough alum, the solution will not be effective. Any excess alum can be kept for a long time in an airtight container.

Flour paste

Paintings should be stretched after they are finished so that the paper does not wrinkle due to the absorption of the inks and water. The traditional method is to back your picture with the same type of paper that you have painted on using a paste made from wheat flour (see page 92).

• Place equal proportions of water and fine wheat flour in a saucepan.
• Heat, stirring continuously until the paste becomes transparent.
• Test before use. If the paste is too thick add more water.

You could also use wallpaper paste. It is just as good as the traditional paste and easier to prepare. You will also need a large soft brush to apply the paste.

Paper towel

Use a white absorbent paper towel to shape brush points, remove excess colour and to mop up spills.

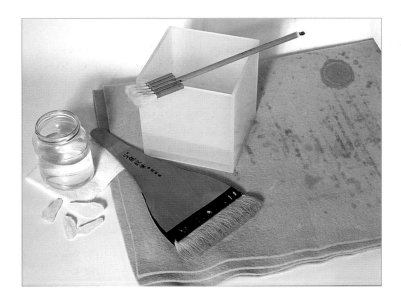

Materials used for backing pictures: clockwise: felt, wide, flat brush, alum crystals, alum solution, brush for applying alum, paste.

Palettes

There are all sorts of palettes available and they are used for mixing colours. I use a pure white porcelain palette, because it reflects the true colour of my mix. I also use a white tile with an uneven surface because It is easier to mix the pools of colour that collect in the lower areas.

Clockwise: palette containing pigment colours, ink box containing ground ink, tiles, brushes, water container.

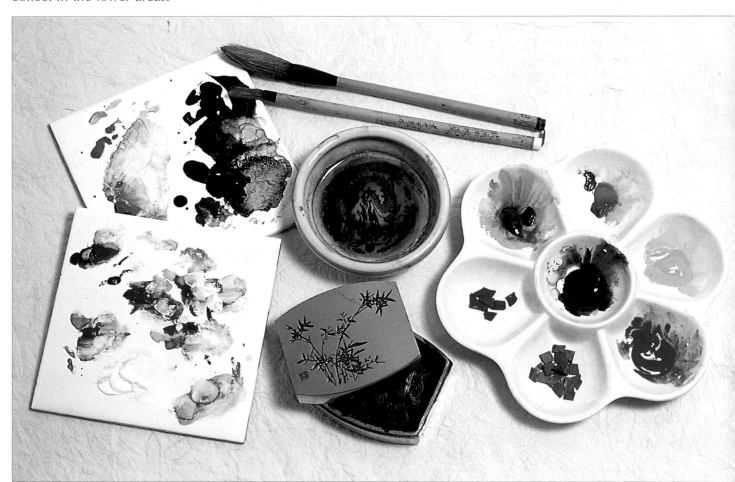

GETTING STARTED

PREPARING THE WORK SURFACE

It is important to be comfortable when you are painting. There is no correct way of laying out your materials, but I find it easier if everything is laid out in the same place. It is part of the philosophy of painting to have everything that you need conveniently placed so that you can reach them easily. If you do this you will not be distracted if you cannot find your brush or your ink stone when you are painting. It is the Chinese tradition that nothing should interrupt your thought processes when you are painting, and that you should concentrate only on the brush strokes and rhythm of working.

It is easier to place your materials within easy reach and always in the same place, although it is not essential. If you do this the flow of your painting will not be interrupted.

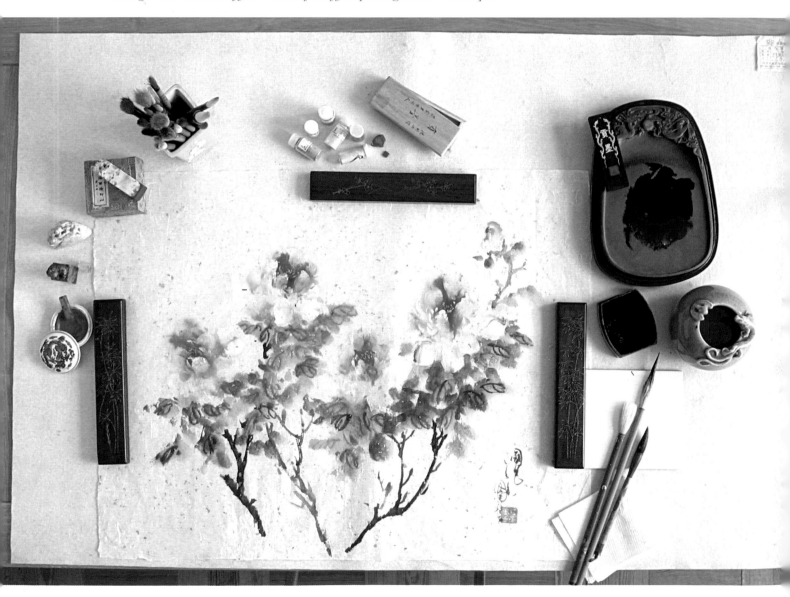

The ink

Black ink is used most, either in the form of an ink stick, or ready-made in a tube. When using an ink stick you will also need an ink stone. First, place a few drops of clean water in the well in the centre of the ink stone. With an even, gentle pressure, hold the stick vertically and grind it in a slow, circular clockwise movement.

After a while the ink will thicken and form a brilliant depth. It needs to be fine and thick, or it will not shine with its full radiance. When tested on paper, it should give you a wonderful variation in tone, so try some brush strokes and make sure you are happy with the results.

Grind only enough ink for your painting and make sure that you dry the ink stick after use, or it will be difficult to use again because of the rough surface. Finally, wash the stone and leave a small amount of clean water in the central well. This will keep the stone in good condition.

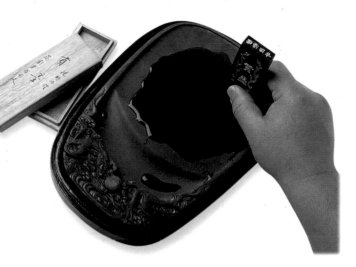

The ink grinding process is an important part of the preparation ritual. It is a time to meditate, to think about your painting and to feel the spirit and essence of your subject. The hissing, grinding sound is very therapeutic and a wonderful ink fragrance will fill your studio.

Loading the brush

There are many different ways to load the brush and this is the basic method. First, the brush has to be prepared. The ink is very dense, and the tip has to be completely clean, so that you can clearly see how much ink is on the brush.

1 Use clean, cold water and wet the bristles thoroughly before use.

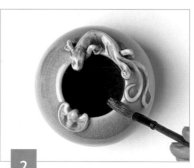

2 Smooth any excess water away on the edge of the water pot.

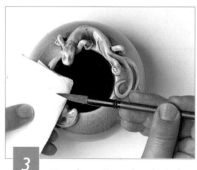

3 Gently wipe the bristles on absorbent paper.

Preparing to paint

Body posture is important. If you are painting a smaller painting you should sit down; if you want to paint a larger picture, it is better to stand up. How you sit or stand depends on the size of your painting.

Generally speaking, if you are sitting down, your body and back should be straight and your shoulders well balanced. Your feet should be placed evenly apart and be firmly on the ground. Your head will fall slightly forwards naturally. Hold the paper down with one hand and the brush in the other hand.

Holding the brush

The best way to hold the brush is upright (see below). It should feel comfortable in your hand so that you can control the strokes. If it is held vertically, you will be able to press lightly or heavily, move the brush slowly or quickly, and diagonally or upright. You will also be able to create curved or straight lines easily. It is this flexibility that make the paintings flow and come to life. If the brush is held at a slight angle, it will produce a richer variety of tone.

Brush strokes

The Chinese brush, with its rounded head and fine tip, is ideal for painting lines and dots, and for creating a wonderful variety of tones, whether you are working on an atmospheric landscape or a beautiful flower. Chinese painting and calligraphy are mainly composed of brush strokes, so the quality of the marks you are making is extremely important.

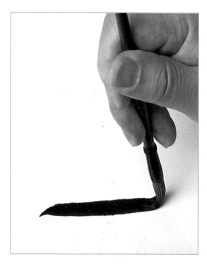

CENTRED STROKE

A full, fluent, energetic straight stroke. Hold the brush firmly in a balanced, upright position with the brush tip in the centre of the line . The thickness of the line is determined by the pressure applied and the speed of the stroke.

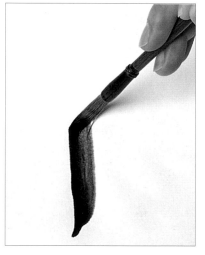

SIDE STROKE

A rich tonal stroke. Load the brush with clean water, then dark ink. Hold it upright, but at a slight angle. The tip of the brush is pressed lightly on the paper so one side only is touching the surface. This stroke is full of contrast.

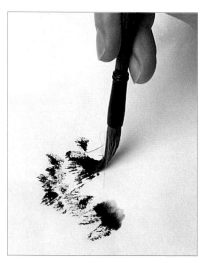

DABBING STROKE

A textured stroke. Hold the brush vertically and press the tip down in a dabbing motion, spreading it out on the paper. This is ideal for painting tree trunks, stones, or any textured surface.

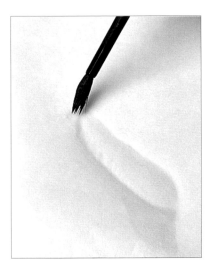

STROKE THROUGH WET

A wet-into-wet stroke. Chinese paper and watercolour paper are absorbent, so a brush stroke on a wet surface will spread, sometimes with surprising results. A small amount of water on the paper will create wonderful wet-into-wet effects. First wet the paper...

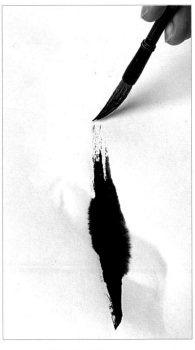

...then pull the loaded brush through the wet area. See how the paint spreads where it touches the wet surface. Alternatively, you could make your brush stroke on dry paper, then add water.

Chinese brush painting is mainly composed of a variety of traditional brush strokes like the ones shown on this page. A combination of these will create any painting.

centred stroke

side stroke

dabbing stroke

wet-into-wet

ROLLING STROKE

A varied stroke. Hold the brush at a slight angle and twist it while you are moving it to create a textured mark. The direction of the stroke is important. If you pull the tip towards you, a smooth line is created. If you push the tip away from you, the result is a broken line. Also, the speed of the stroke is important. In general, a fast movement causes less variation in tone and a slow movement causes more variation.

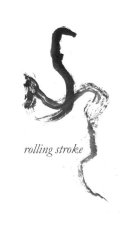

rolling stroke

CALLIGRAPHY

Calligraphy is as important as the picture and seal in Chinese art. A painting is not truly complete without the expression of an idea, a poem or a quote or the stamp of ownership. The artist's emotions, energy, strength and personality are frequently captured in the beautiful calligraphic script, which is as carefully placed on the paper as the subjects that are being portrayed.

Throughout the history of Chinese art, paintings and calligraphy have shared the same type of brushes, techniques, paper and ink. Combined with the seal, the whole composition must have meaning and a harmonious balance. A painting might contain a few simple characters, a proverb or many inscriptions; it depends on what the artist wants to express.

There are mainly five different Chinese styles: regular script, cursive, official, seal character and running script. Regular script was used in China more than 1,700 years ago and is still the main writing style today. Usually, this is the script you would start learning, then you would go on to study the various other scripts. To express yourself fully and to develop your own style, you would need to understand them all and to practise them with your painting techniques.

THE EVOLUTION OF CHINESE CHARACTERS

It is thought that Chinese writing goes back six thousand years or more. Each character was a picture, as shown in the left-hand column below. As you can see, the mountain character is peaked like a mountain and water is a series of flowing strokes. Modern writing – Running hand, which is shown in the right-hand column, has evolved slowly over the centuries, with characters still retaining their elegance but in a different form.

	Seal	*Official*	*Regular*	*Cursive*	*Running hand*
Sun	日	日	日	日	日
Moon	月	月	月	月	月
Mountains	山	山	山	山	山
Water	水	水	水	水	水
Fire	火	火	火	火	火

BASIC TECHNIQUES

There are approximately fifty thousand Chinese characters, but only about six thousand are used regularly, and all these characters have no more than eight types of stroke (below). Practising these simple strokes will hopefully encourage you to learn more about Chinese calligraphy, which is an important part of the painting process.

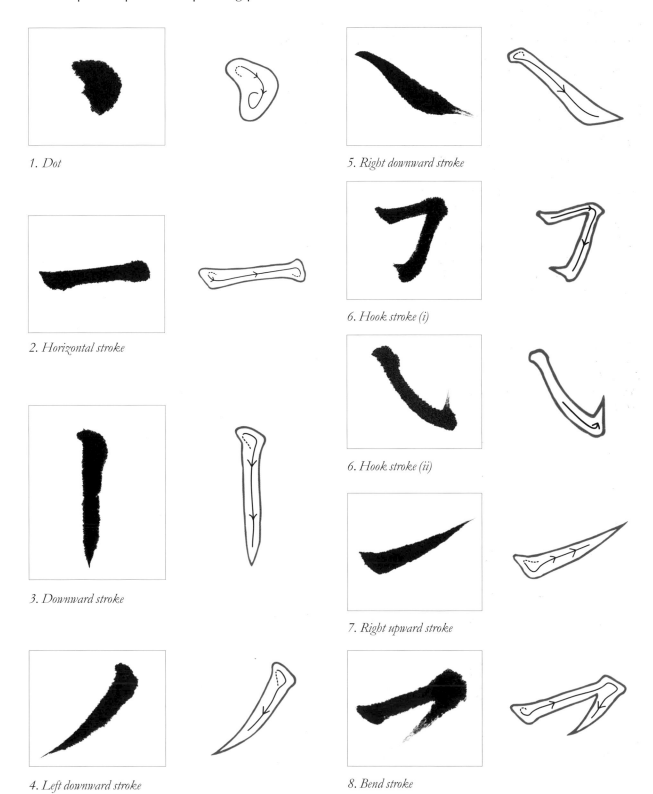

1. Dot

2. Horizontal stroke

3. Downward stroke

4. Left downward stroke

5. Right downward stroke

6. Hook stroke (i)

6. Hook stroke (ii)

7. Right upward stroke

8. Bend stroke

Forever

This simple project teaches you how to create one character, which translated means *forever*. This is the most commonly used teaching word because it is gracefully composed, balanced and it contains all the main strokes. Use a medium soft brush and follow the direction of the arrows shown in the diagram. Each stroke is one flowing movement of the brush. Think of the strokes as a dance and allow the brush to move rhythmically over the paper, so there is life in the character.

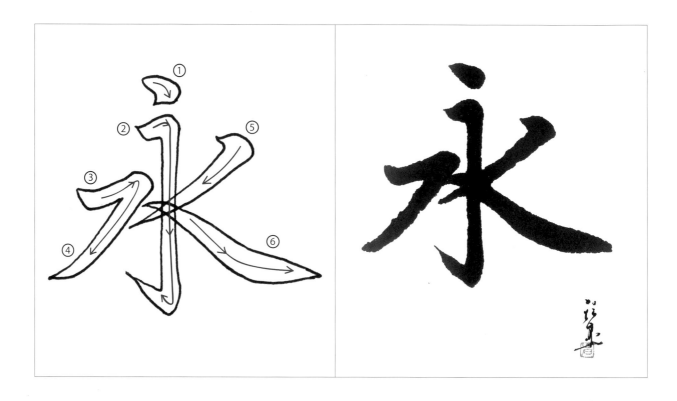

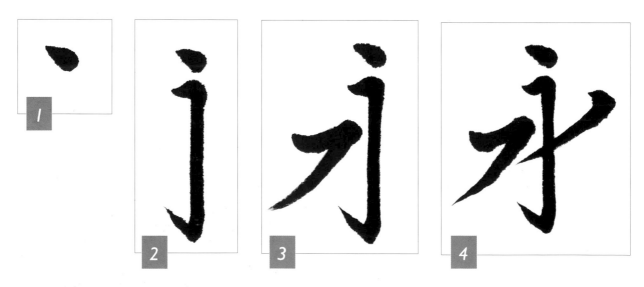

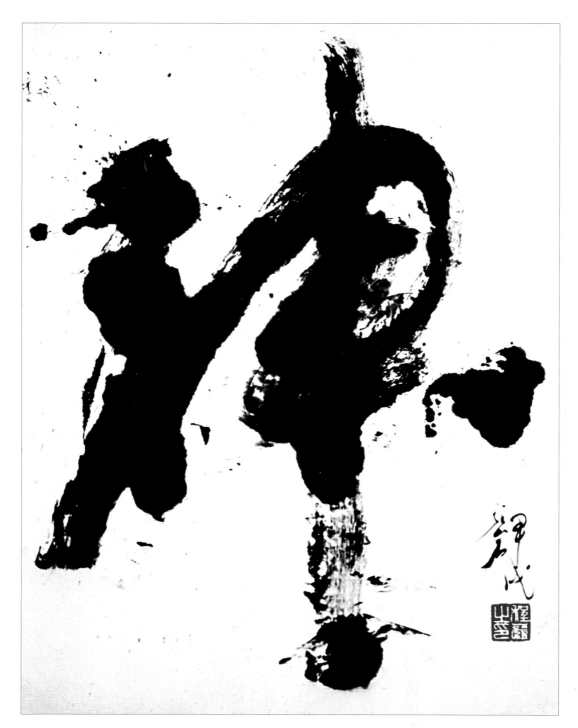

GREAT SPIRIT

This is a strong piece of calligraphy with bold, expressive brush strokes on Xuan paper. I used a large soft brush and worked rhythmically, following the flow of the letters with some wet and some dry strokes.

<div align="right">

Overleaf
Heron in autumn pond
This painting combines traditional and modern techniques. I used Mulberry paper with a string texture, black ink and an earth brown pigment. The ink background was washed in first, then the autumn lotus leaves were painted in with large, expressive brush strokes. The heron was added when the paint was dry, with the bird's feathers and markings painted in carefully. Gouache highlights were then added on the top of the body and head.

Size of painting: 510 x 420mm (20¹/₄ x 16¹/₂ in)

</div>

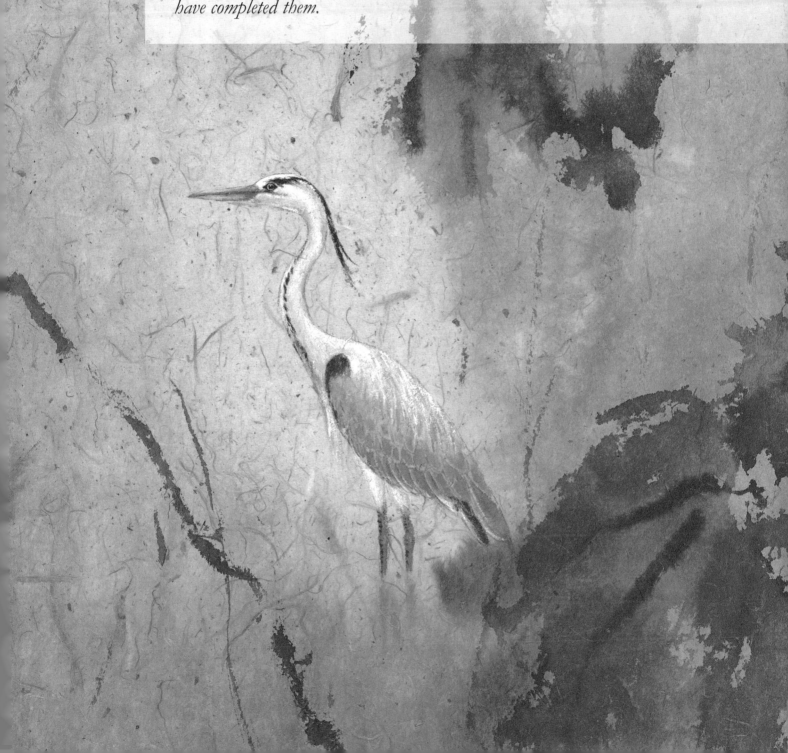

DEMONSTRATIONS

There are many symbolic meanings in Chinese art and they have great significance. Paintings also express the thoughts and ideas of the artist. The combination of symbolism, philosophy and the beauty of the brush strokes is a compelling mix. These demonstrations will help you understand some of the symbolism and the techniques, and hopefully you will be inspired to learn more about this fascinating art once you have completed them.

BAMBOO

Bamboo is a luxuriant, tough, upright evergreen plant which survives intense cold in winter, therefore it symbolises strength, energy and vitality. It also symbolises modesty, nobility and gentleness.

Throughout history, this sturdy plant has been used by many Chinese scholars and artists, in painting, calligraphy and poetry, to express their philosophies and ideas. When bamboo is portrayed with plum blossom and pine, the three are called the *'Three Friends of Winter'*. When portrayed with plum blossom, an orchid and a chrysanthemum, the four are called the *'Four Gentlemen of Noble Character'*.

Bamboo

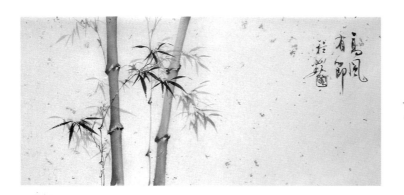

This first project is an ideal introduction because it involves the use of all the brush stroke techniques. Relax and give yourself time to think about the shape of the bamboo and its qualities before you begin painting. Make sure you have prepared enough ink so that your painting flow is not interrupted.

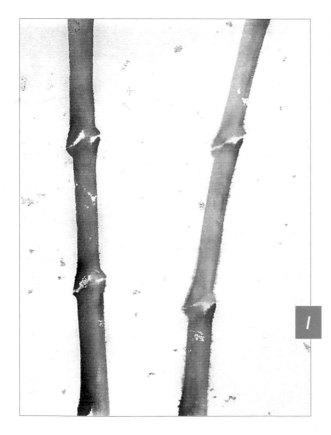

MATERIALS

340 x 130mm (13³/₈ x 5¹/₈in) sheet of sized, fine Xuan paper with gold flakes
Fine, stiff long-tipped brush
Medium round brush
Large soft brush
Black ink

1 Using the medium brush, load the bristles with clean water and pick up enough ink for one pole. Using a side stroke work upwards and paint the first section, leave a small unpainted area then repeat the stroke for the second section, then the third. Remember, when using a side stroke variation of tone is important.

2 Before the main strokes are dry, use the stiff brush with the fine tip to paint in a curved darker areas between the sections.

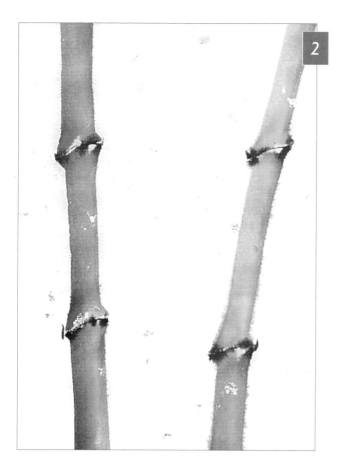

Add dark foreground branches with finely drawn lines which divide and taper at the ends, using the small stiff brush. Then add fine background twigs.

3

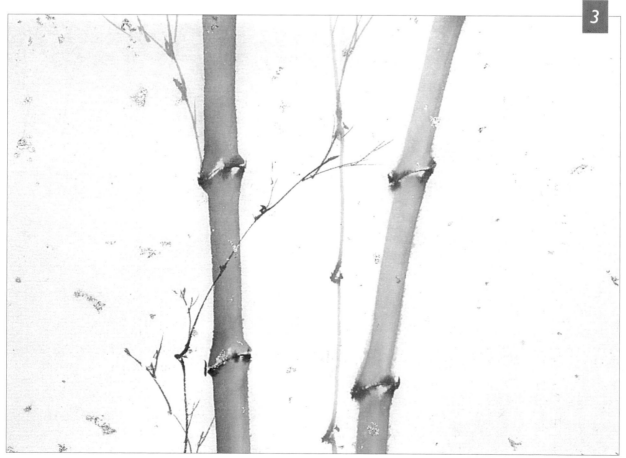

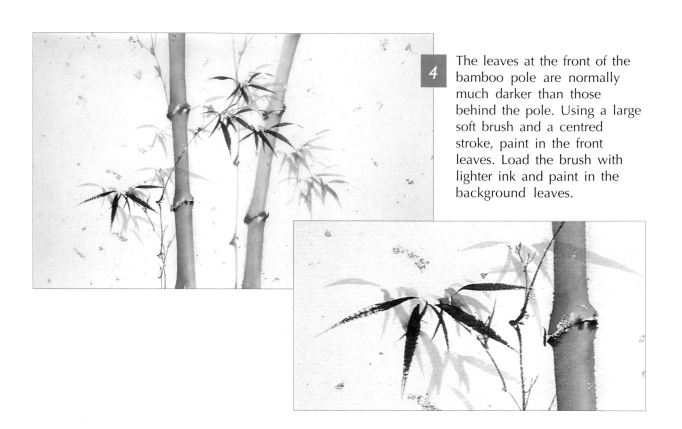

4 The leaves at the front of the bamboo pole are normally much darker than those behind the pole. Using a large soft brush and a centred stroke, paint in the front leaves. Load the brush with lighter ink and paint in the background leaves.

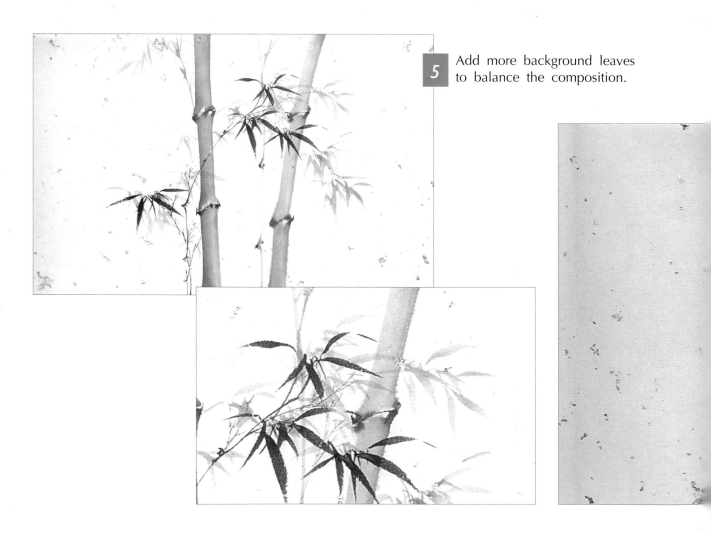

5 Add more background leaves to balance the composition.

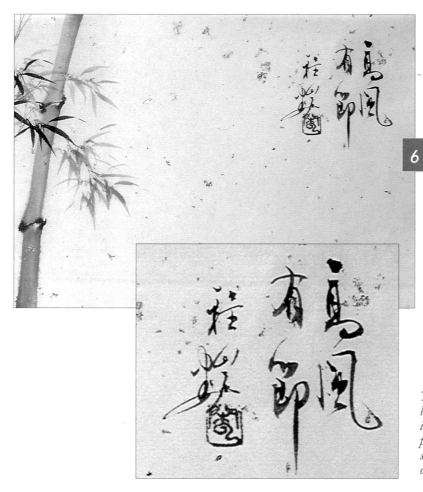

6 Add the calligraphy with a medium mixed brush, as shown on page 32, and the seal following the instructions on pages 18 and 26-29. Finally, mount the painting on raw Xuan paper as shown on pages 92–94.

This calligraphic inscription praises the bamboo plant for its noble character. The seal is my name seal and it appears on all my paintings. In complete harmony with the subject, the two elements complement each other, and the graceful bamboo.

The finished painting

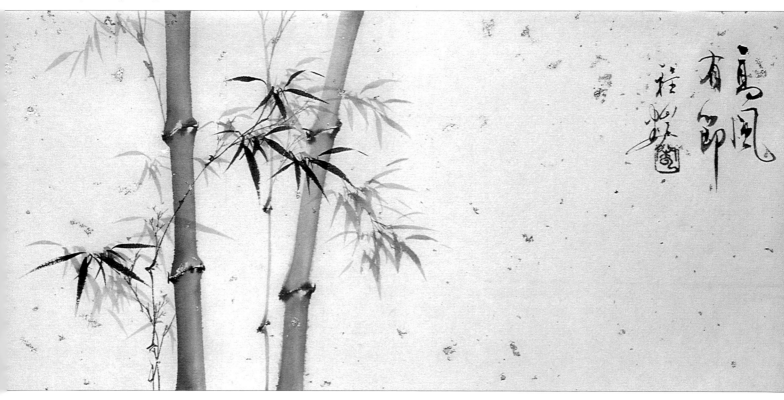

ORCHID

The orchid, with its elegant evergreen leaves and sweet smell, has inspired Chinese artists and poets for centuries. It is also known as 'good friend' or 'orchid friend' in China. Normally found hidden away in secluded places, this flower symbolises beauty, peacefulness, virtue and love. Beautiful paintings or poems are often referred to as 'orchid work'.

Orchid

Simplicity is of the utmost importance when painting orchids. Here I show the traditional composition, which will form the frame for the flower heads. These will be created with a few simple brush strokes.

MATERIALS

270 x 220mm (10⅝ x 8⅝in)
sheet of raw Xuan paper
Medium mixed brush
Small fine-haired brush
Black ink

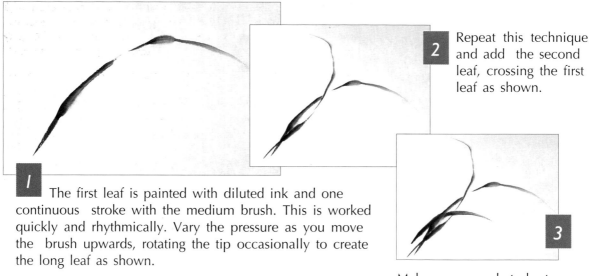

2 Repeat this technique and add the second leaf, crossing the first leaf as shown.

1 The first leaf is painted with diluted ink and one continuous stroke with the medium brush. This is worked quickly and rhythmically. Vary the pressure as you move the brush upwards, rotating the tip occasionally to create the long leaf as shown.

3 Make an upward stroke to create the third leaf in the same way.

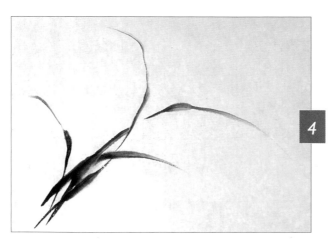

4 The fourth leaf resembles the first. So paint it with one continuous stroke as in Step 1. These leaves form the framework for the flowers.

There are five petals on this orchid flower. Using the same brush and diluted ink, paint in the front petal from the tip towards the flower centre.

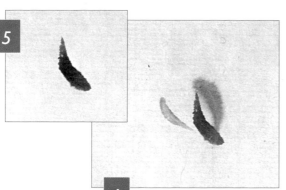

5

6 Dilute the ink with more water and brush in the next two petals in the same way, working from the tip inwards.

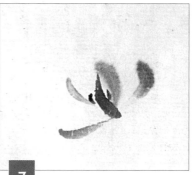

7 Using the diluted ink, brush in two more petals to complete the flower, then add two small strokes to represent the anthers.

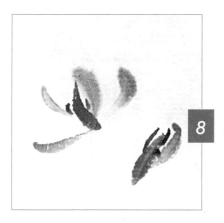

8 Three strokes from the petal tips to the flower base form the bud.

The finished painting. The stems grow in the same direction as the leaves and a single stem can support many flowers and buds. Each one is painted in using the small fine-haired brush and continuous upward strokes. The nodules are created by slightly interrupting the flow of the brush.

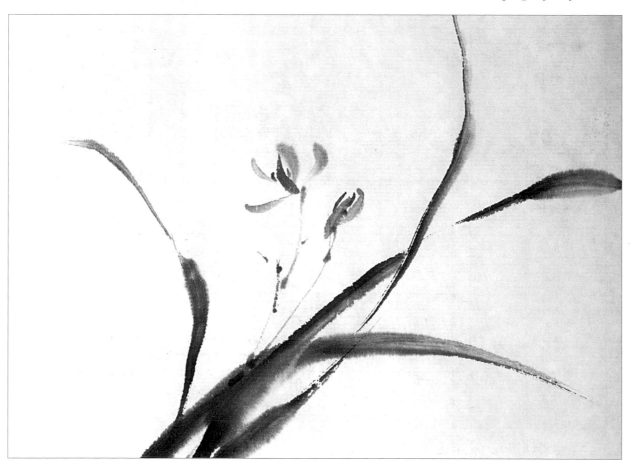

PLUM BLOSSOM

Beautifully coloured plum blossom heralds the coming of spring. As it is the first blossom of the year, it is deemed to be a lucky flower, and the symbol of purity and nobility. It has been a favourite subject of artists and poets throughout history.

Plum blossom

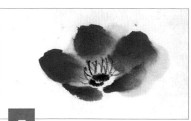

When painting blossom work on the branches first, dividing them into smaller branches with long, tapering brush strokes which are pulled towards the branch ends. Here, I show you how to create a single bloom with just one brush stroke for each petal. You must work quickly to achieve the desired effect. The blooms are then massed together as shown opposite.

1 Load the medium brush with water, then red paint, and brush in the first of the five petals with a side stroke.

2 Working quickly, brush in the second petal . . .

MATERIALS

Raw Xuan paper
Small round soft brush
Medium round soft brush
Chinese watercolour: red
Black ink

3 Now brush in the third.

4 Brush in the fourth petal using the same brush and less pressure . . .

5 . . . and the fifth petal.

6 Now load the small brush with black ink and brush in two strokes to create the flower centre.

7 Use the brush tip to add the filaments of the stamens.

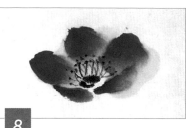

8 Finally, add tiny dots to define the anthers.

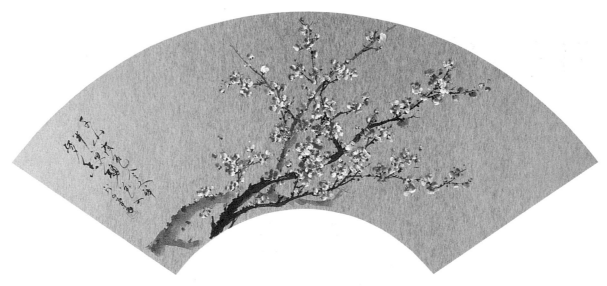

PLUM BLOSSOM FAN

The fan is a shape that is often used in Chinese art. Here the blossom is painted on a fan of gold paper using ink, Chinese watercolours and gouache. The darker front branches are painted in first with a medium brush and black ink. The lighter branches are added, following the curve of the darker strokes. This gives a sense of depth. The blossom is added using tones of pink and white gouache, then the final details are touched in with a small brush. The calligraphy and seal are carefully placed so that they balance the picture.

Size of painting: 460 x 210mm (18 x 8½in)

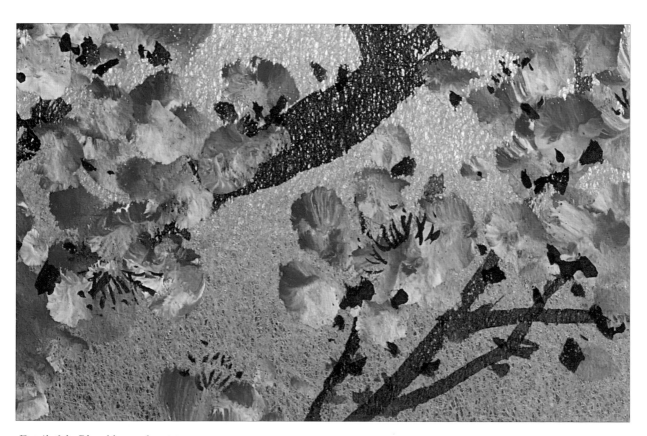

Detail of the Plum blossom fan.

The branches are brushed in from left to right, with the strokes tapering off to fine points. The blossoms should never all face the same way, so vary the angle and brush the petals in as shown opposite. Here, varying pink tones are overlaid, and white highlights added, then the stamens and final details are touched in.

PEONIES

The peony is China's national flower and it has always been popular in Chinese art. For centuries painters have portrayed the beauty of the peony which symbolises spring, love, good fortune and longevity. Poet Li Zheng praised the peony as 'the flower with heavenly sweetness and with national beauty'. Here it becomes an expression of prosperity, peace and happiness.

Peonies

There are many ways to paint the peony in Chinese brush painting. In the Xieyi style the brush strokes are free and flowing. The Gongbi style contains much more detail. Compositions vary, but the emphasis is always on harmony and the essence of the subject. Before you start to paint, think about the composition and feel the beauty of the flower.

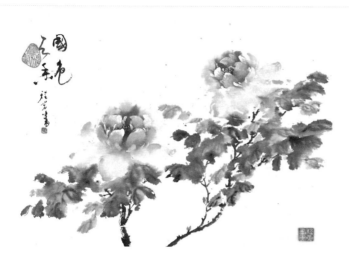

1 Use your fingernail to mark two circles on the paper to define the position and shape of the flower heads.

MATERIALS

600 x 440mm (23 5/8 x 17 1/4 in) raw Mulberry paper

Paper towel

Water sprayer

Small long-haired brush

Medium long-haired stiff brush

Medium round soft brush

Large soft brush

Large stiff brush

Black and blue ink

Chinese watercolours: peony red, rouge tint, bright yellow, blue (dark), mineral green and mineral blue

Gouache: zinc white

Dry pigments: mineral blue, gold

Painting glue

Using the water sprayer and clean water, wet the surface of the paper where the two flower heads are going to be brushed in.

Using absorbent paper, dab off any excess water. The colour will run into these areas creating a beautiful wet-into-wet effect.

4 Prepare your colours. I have used a white porcelain tile as a palette. Squeeze peony red, rouge tint and zinc white on to the surface, making sure you have enough paint for the picture.

5 Wet a medium round brush in clean water, then load the bristles with peony red...

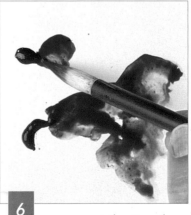

6 ...now wet the tip of the brush, and load a small amount of rouge tint.

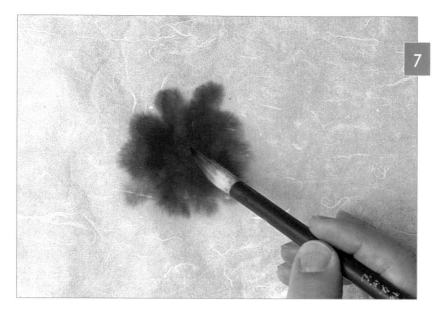

7 Mark the centre of the flower with the tip of the brush then make a series of centred straight strokes around this point to create the inside petals. As the paint spreads into the wet surface, the colour will became lighter towards the edges.

Pick up some more rouge tint from the palette with the tip of the brush, and darken the centre of the flower more. 8

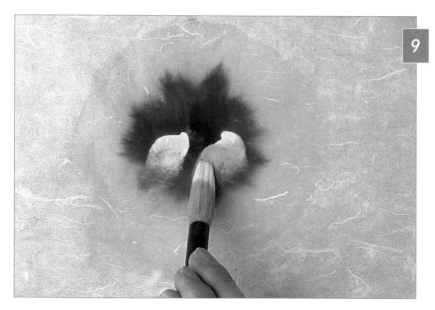

9 Load the large soft brush with zinc white, add a touch of peony red to the tip, then start to brush in the inner petals working from the centre of the flower towards the edges. There are several layers of petals, so continue adding more. . .

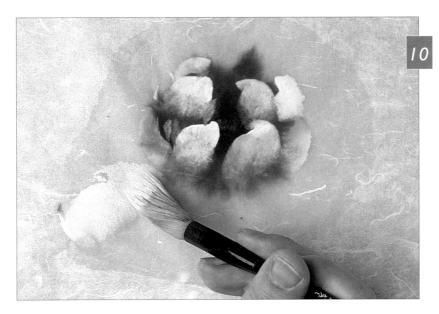

10 . . . then, using the same brush and zinc white, start to paint in the first of the large outer petals. Using side strokes, pull the brush towards the centre of the flower, twisting it slightly.

When the outer petals have been painted, use the tip of the brush to make small highlights here and there. 11

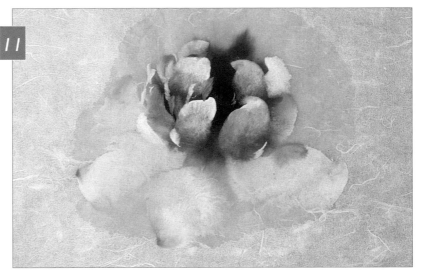

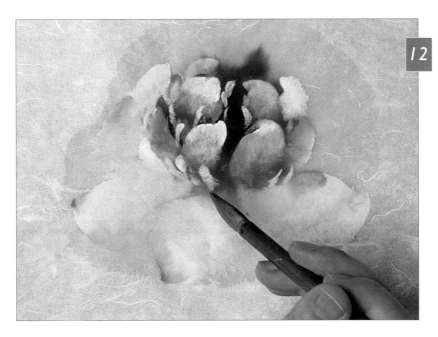

12 Using the medium round brush add shadows behind the petals with touches of bright yellow and rouge red. This will give the flower depth and create a feeling of fullness.

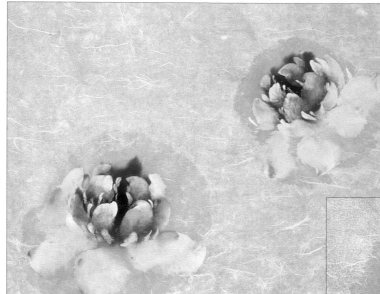

13 Repeat steps 5–12 and paint the second flower in the same way. The two flowers are angled differently, so the petals, highlights and shadows need to be altered slightly as shown.

Detail of the second flower

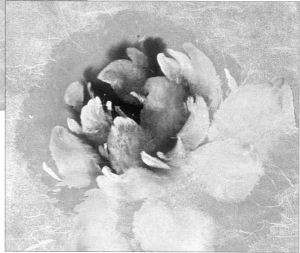

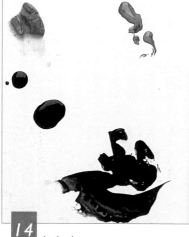

14 It is important to prepare your colours before you paint, so that you can work freely and without interruption. The next set of colours you will need are the leaf colours: mineral green, mineral blue. You will also need blue and black ink.

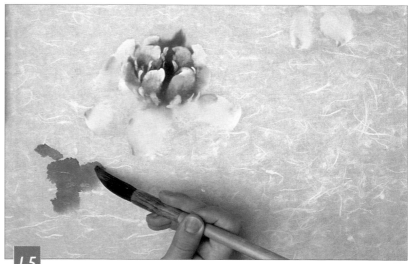

15 Load a large soft-haired brush with mineral green, then dip the tip in mineral blue. This variation of colour on one brush is vital. It creates more life in a painting and makes the images more vivid. Brush in the first leaf on the left-hand side of the painting.

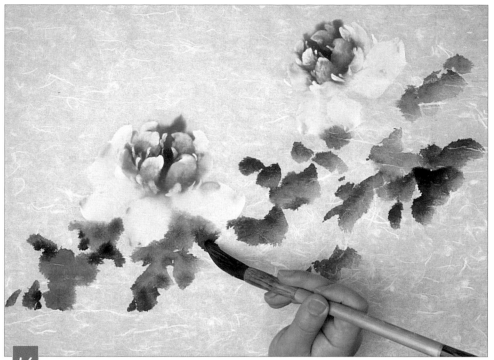

16 Working quickly, move across the painting, brushing in the leaves. Vary the tones by loading the brush with more colour. Add dark touches of the same colours to some of the paler leaves where the shadows fall.

Add a touch of black ink to the tip of the brush and work darker shadowed areas into some of the leaves.

17

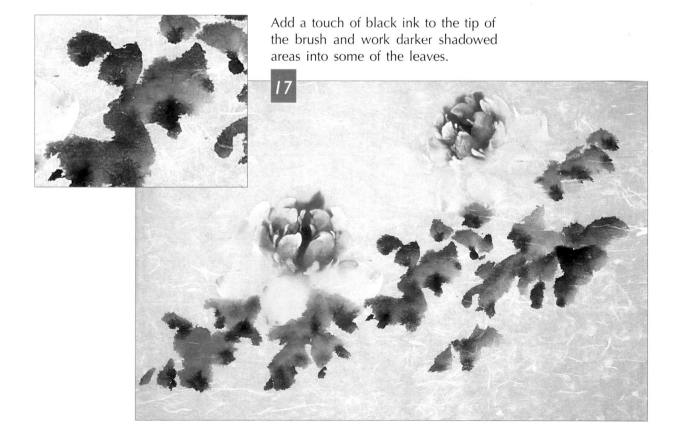

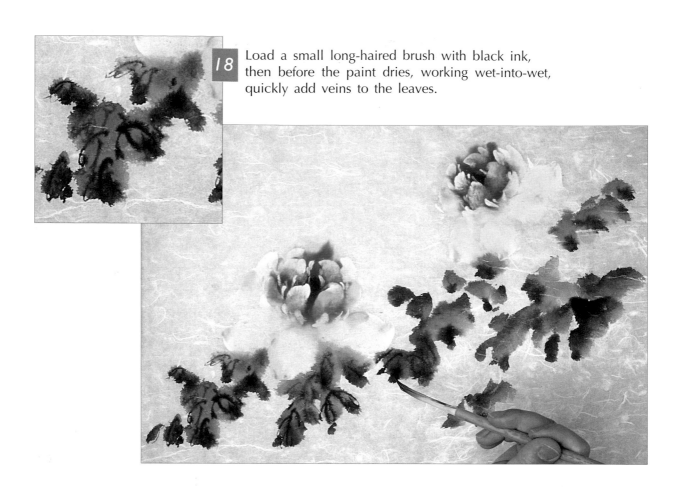

18 Load a small long-haired brush with black ink, then before the paint dries, working wet-into-wet, quickly add veins to the leaves.

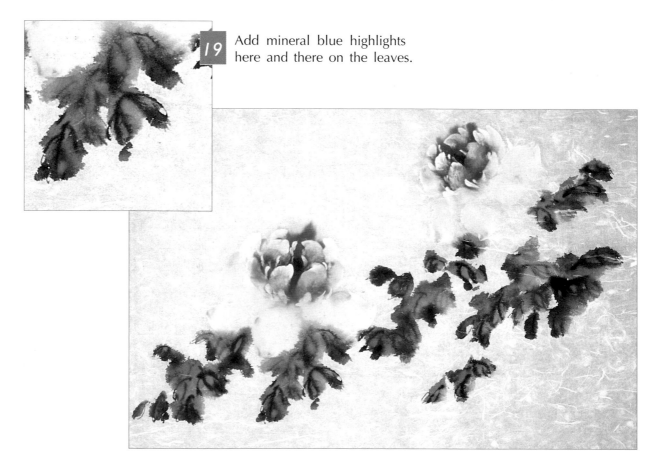

19 Add mineral blue highlights here and there on the leaves.

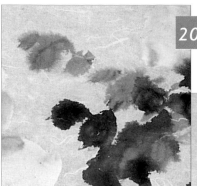

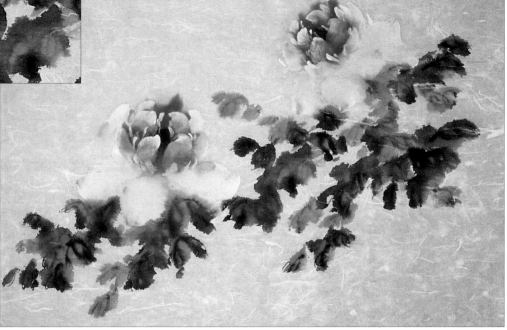

20 Add water to the colours to dilute them, then paint pale-coloured leaves in between the darker ones. Add deeper shadows, then use a weak black ink wash for the veins on these paler leaves.

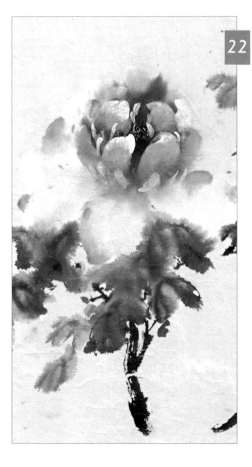

22 Paint in the tapering branches amongst the leaves, following the line of the main stem. As you work upwards towards the flower, add smaller branches using the same dark tone.

21 Wet the tip of the medium long-haired brush, semi-load it with black ink, then use dry brush strokes to start painting the left-hand flower stem. Pull the brush upwards with a rolling stroke to create texture.

47

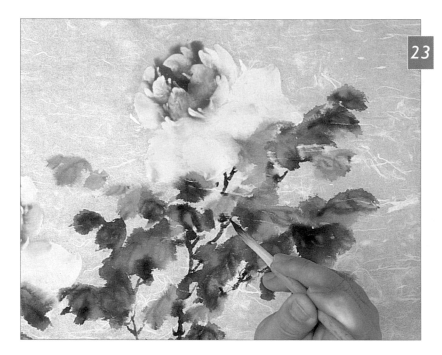

23 Brush in the stem on the other flower in the same way, branching and tapering it upwards towards the flower head. The leaves form a canopy around and over the stem, so paint carefully up to their edges. This will give the impression that the foliage is in front of, and behind the stem.

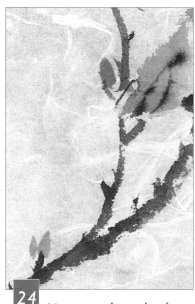

24 Use a weak wash of peony red and brush in a few leaf buds on the end of the branching stems with one simple centred stroke.

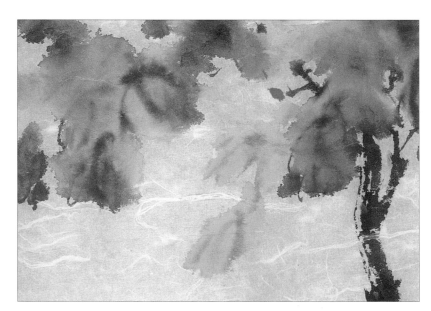

This detail at the bottom left-hand corner of the composition was photographed after all the colours had been allowed to dry. Notice how the wet-into-wet brush strokes have softened and blended together.

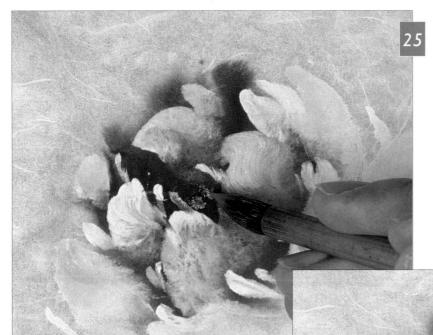

25 Mix mineral blue pigment with a little painting glue on the palette. Using a medium soft brush, wet the tip of the bristles, dip them in the mixture and add dots of colour in the centre of the flower.

26 Mix gold pigment with a little painting glue on the palette. Clean the brush thoroughly. Wet the tip, dip it in the mixture, then add the stamens.

27 When the painting is finished, the calligraphic inscription is added using black ink and a medium brush. It is important not to disturb the balance of the painting, so the characters are carefully placed, then the seals are stamped on to complete the picture (see page 19). Finally, mount the painting on raw paper as shown on pages 92–94.

Overleaf
The finished painting

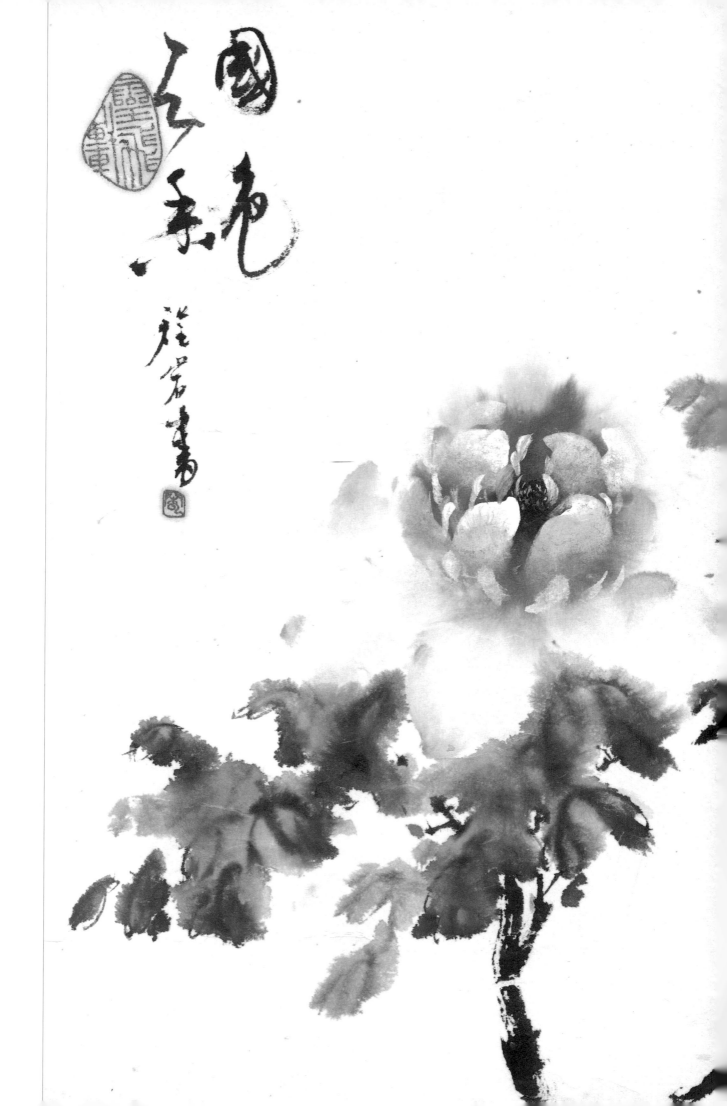

國色天香 莊嚴書

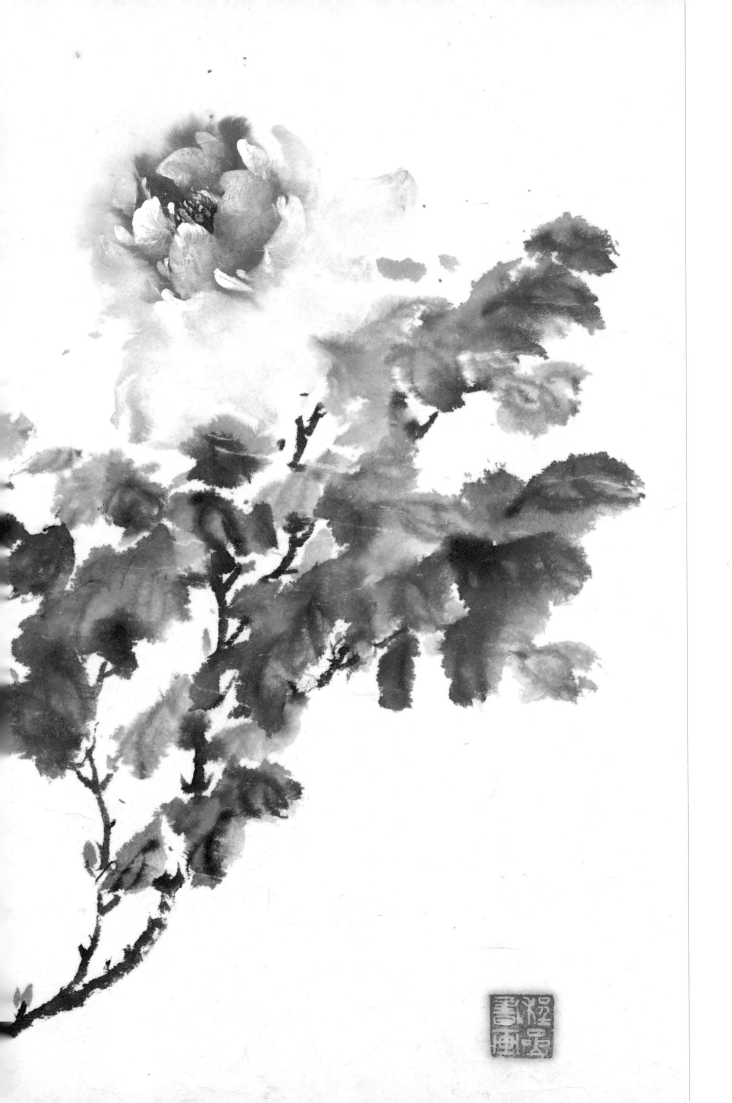

CHRYSANTHEMUM

The chrysanthemum is much loved in China. It blooms after the passing of summer when other flowers have withered away, and it can withstand the blasts of chilly winds and cold weather. This beautiful flower is highly honoured for its noble characteristics and is widely used to express good wishes. A painting containing a chrysanthemum and a maple leaf means 'live and work in peace and contentment'; if a chrysanthemum is shown with a pine tree it means 'longevity'; a chrysanthemum painted with a magpie is regarded as 'bringing joy to the family'.

Chrysanthemum

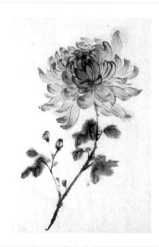

Remember to spend some time thinking about your subject before you begin. Meditation combined with the sweet smell of chrysanthemums and a cup of tea is a wonderful thing.

MATERIALS

140 x 210mm (5½ x 8¼in) raw
Xuan paper
Medium soft brush
Medium stiff brush
Large soft brush
Black ink
Chinese watercolours: dark yellow,
Light yellow, mineral green

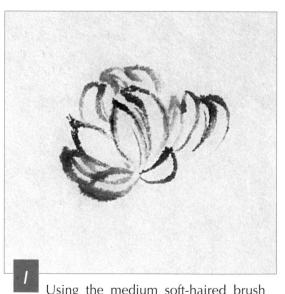

1 Using the medium soft-haired brush and diluted black ink, outline the petals. Start at the tip of the petals in the centre, and pull the strokes downwards. The petals should be slightly darker at their tips.

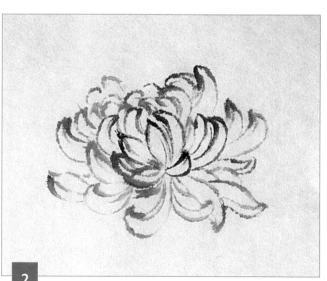

2 Keep adding more petals, building up the flower head and working outwards.

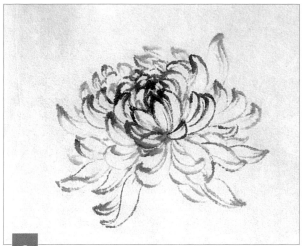

3 Adding looser petals around the outside of the flower head gives a feeling of life and vitality. Add these final petals with a weaker mix of water and ink.

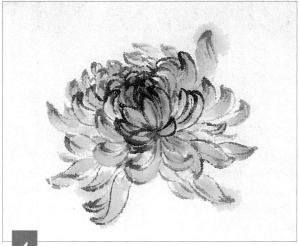

4 Brush dark yellow into the centre petals, and lighten the tones with light yellow as you work outwards. Do not worry if the colour wanders outside the ink lines. This will add to the feeling of vitality.

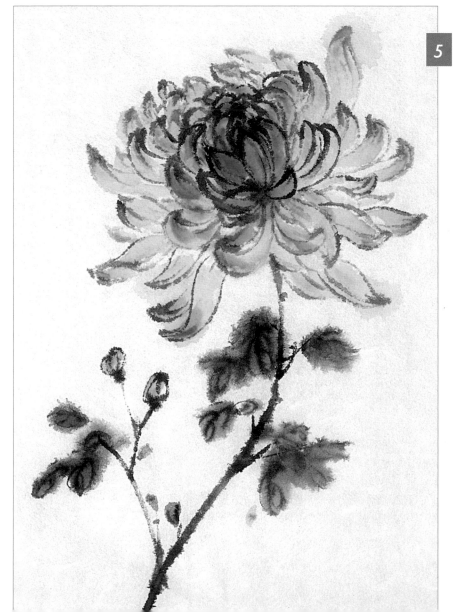

5 Paint in the stem with a centred stroke using a medium stiff-haired brush and black ink. Start at the bottom and work upwards, tapering the stroke and adding smaller stems, following the curve of the flower. Paint in the leaves with the large soft-haired brush, following the same techniques used on the peony (see pages 44–47). Next, add the buds to balance the composition. Finally, mount the painting on raw Xuan paper as shown on pages 92–94.

LANDSCAPES

Landscape painting in Chinese art is known literally 'the painting of mountains and water'. This includes trees, rocks, clouds and other elements, as shown on the next few pages, but the main emphasis is on the drama and grandeur of the landscape. It is important to remember that each element should combine to create a whole image that evokes thought and emotion. Our minds should be set free as we look at the scene before us.

There are two ways to learn how to paint landscapes: the study of traditional techniques or the study of nature. The traditional techniques are shown on the following pages. Studying nature will bring rich rewards, so explore the landscape and follow the inspiration in your heart. Whether it is a lake, a mountainous scene like the one below, a river or a misty woodland, the magic of the landscape is there to be found. Look at the shapes around you. Feel the atmosphere and use the techniques in this book to create your own paintings.

Landscapes

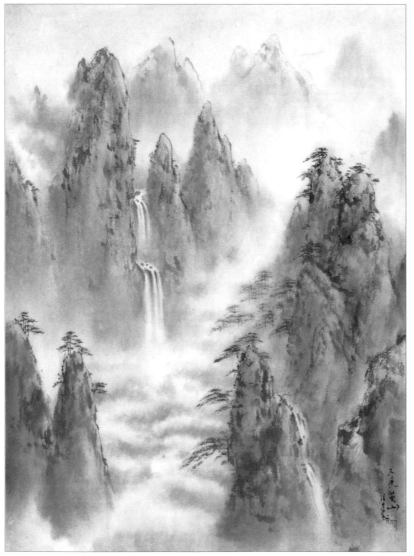

MOUNTAIN MIST

The mist nestles in the folds and valleys of Huang Shan mountain adding to the drama and grandeur of the landscape. The distant peaks are washed in lightly and stronger colours are brushed into the foreground. This gives a wonderful feeling of space and depth. I visit this mountain whenever I can, and when painting it, I am recreating the feelings I have when I stand in front of this amazing view.

Size of painting: 290 x 390mm
(11³/₈ x 15³/₈ in)

Opposite
FISHING IN THE SPRING RIVER

Painted on Xuan paper using black ink and light mineral green Chinese watercolour, this painting is the memory of an early spring morning after the rain has fallen. The whole paper was washed with water first, then the far mountains were brushed in. Reflections are not painted in traditional Chinese paintings, but I decided to add them in this picture.

Size of painting: 285 x 390mm
(11¹/₄ x 15³/₈ in)

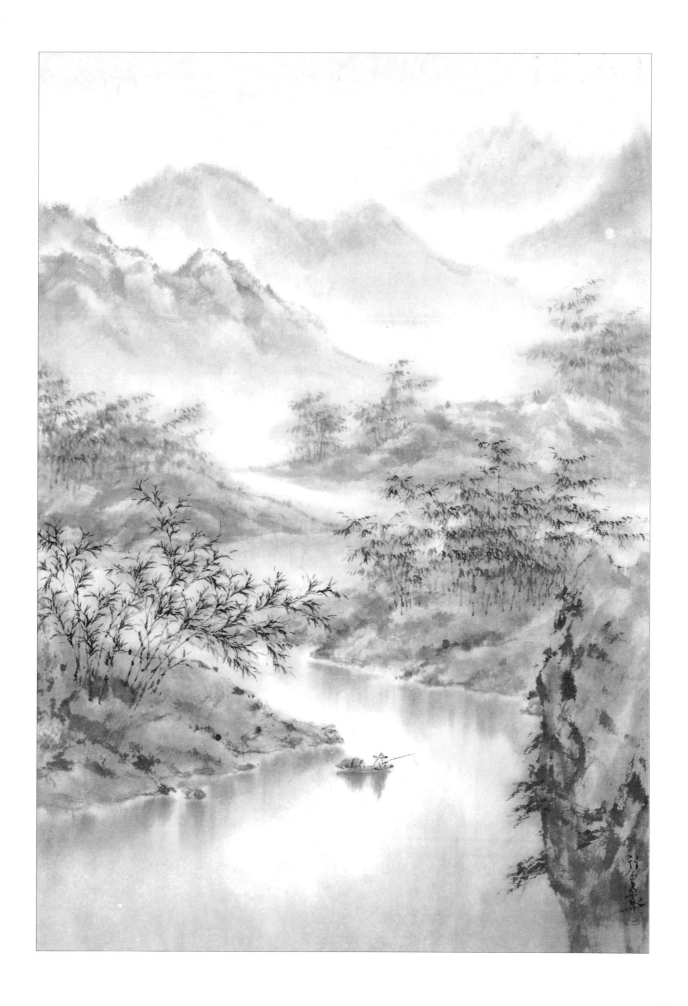

ROCKS

Rocks are an important part of landscape painting. Generally, when you are learning how to paint landscapes, you will begin by painting one rock. The technique involves linework and then building up tone and texture. This can also be applied to larger rocky areas, hills and mountains.

MATERIALS

200 x 145mm (7⅛ x 5¾in) sheet of half-sized Xuan paper
Medium mixed brush
Large soft brush
Black ink
Chinese water colours: blue

1 Draw in the outline of the rocks with the medium brush and diluted black ink.

2 Add mid-tones, leaving the white of the paper to represent highlights. Use side brush strokes to create a textured effect.

3 Use stronger tones to develop the areas in shadow.

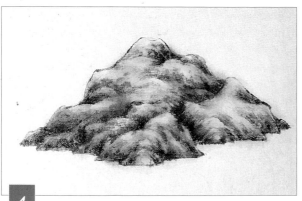

4 Mix a weak blue wash using the large brush, adding strokes here and there to create a feeling of roundness and depth.

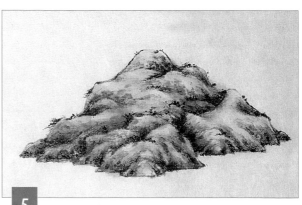

5 Finally, using the medium brush and black ink, suggest moss and grasses on the rocks.

TREES

A tree can be divided into three sections: branches, trunk and roots. In traditional painting branches can be generalised into two types: the upward growing 'deer horn' and the downward growing 'crab claw'. There are many different types of trunk because there are so many different trees. It is worthwhile studying them before you paint them, so that you understand their characteristics. The roots connect the tree to the ground and they are as important as the branches and the trunk. Their gnarled and twisted forms add interest to the painting.

MATERIALS

150 x 200mm (5⅛ x 7⅞in) sheet of half-sized Xuan paper
Small stiff brush
Medium stiff brush
Black ink

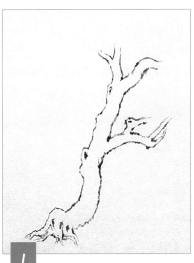

1 Using the medium brush and black ink, brush in the outline of the trunk.

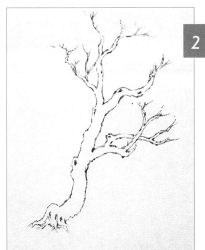

2 Using the tip of the brush, draw in the tapering branches.

With the small brush, add the finer branches and twigs, then add some dark shadowed areas.

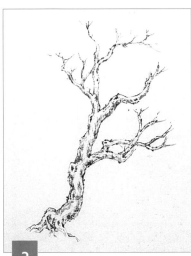

3 Using a brush loaded with only a little ink, touch the tip on the surface to produce small texture marks all over the trunk and branches.

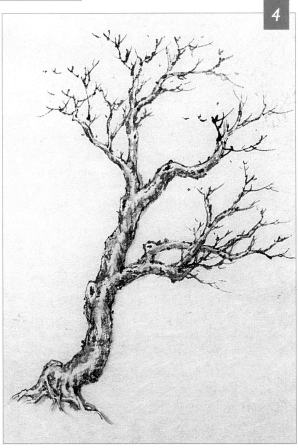

4

WATER

Water is an important element: it gives life to a landscape. Running water symbolises longevity and prosperity. I always like to include water in different forms in my landscape paintings; without it, paintings can be lifeless and dull. Here, the waterfall springs joyfully over the rocks, cascading into the valley below. Soft washes give the impression of falling water and darker tones bring out the texture of the rocks.

MATERIALS

310 x 410mm (12 x 16in) sheet of
raw Xuan paper
Small stiff brush
Medium soft brush
Large soft brush
Chinese watercolours: blue
Water sprayer

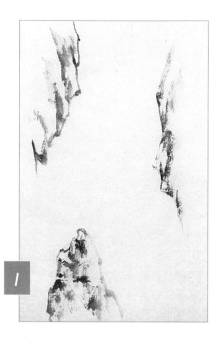

1 Using black ink and the medium soft brush, outline the rocks around the waterfall. Brush weaker tones in to create a feeling of shape and texture.

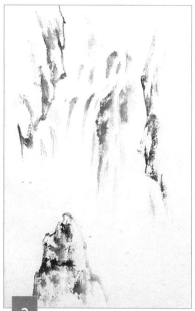

2 Add the tops of a few small rocks within the waterfall to suggest the flow of water.

3 Brush in diluted ink washes over the rocks. The craggy forms immediately spring into life and create the impression that they are containing the water and restricting its flow.

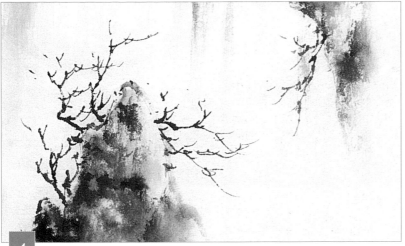

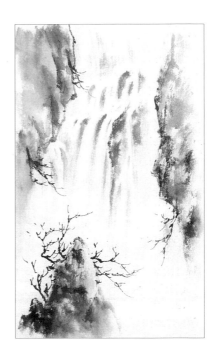

4 With the small stiff brush, add dark trees among the rocks. Use thick, tapering strokes so that they appear to be clinging precariously to the rocky surfaces. The dark shapes against the spray add to the perspective and feeling of depth.

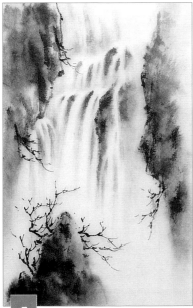

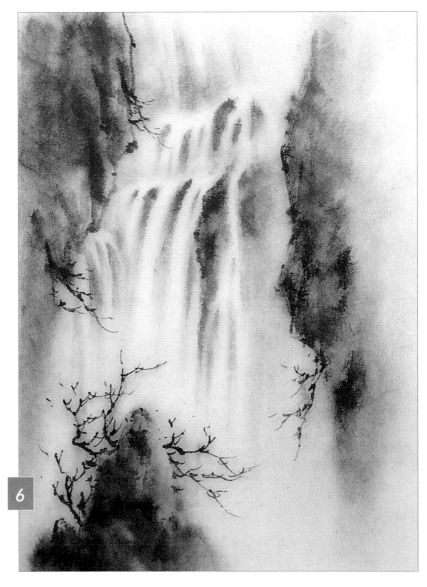

5 Spray the paper with water, then use washes of black ink in areas, working wet-into-wet to reduce any hard edges. This will enhance the feeling of perspective even more.

6 Thoroughly dry the paper to seal the ink, respray with water then using the large soft brush, apply a weak blue wash, wet-into-wet, over the rocks.

SPRING RIVER

The willow and the cherry tree are symbolic of spring. In this demonstration, a weeping willow stands proudly in the winter landscape while a flowering cherry joyously heralds the coming of spring. The winter willow evokes a feeling of solitude, while the small flowering cherry tree offers hope for a new beginning.

Spring river

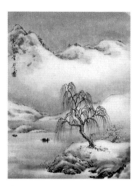

This demonstration contains all the basic elements of a landscape painting: rocks, trees, water and mountains. The fisherman and his boat have been added in the traditional way as a focal point, and to add balance and interest to the painting. The scale of the landscape is helped too, by the grandeur of the mountains and the leaning willow framing the tiny craft as it floats on the peaceful river.

MATERIALS

300 x 400mm (11¾ x 15¾in) sheet of raw Xuan paper
Small long-haired brush
Medium stiff brush
Medium soft brush
Large soft brush
Black ink
Chinese watercolours: blue, turquoise, peony red, light brown
Gouache: zinc white
Water sprayer

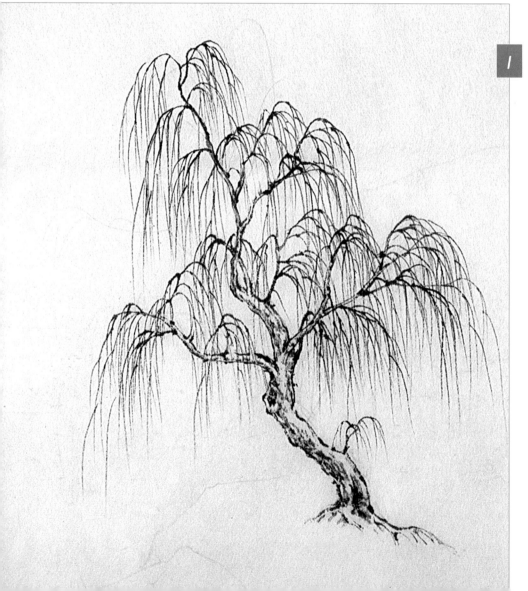

1 Using the medium stiff brush and black ink, brush in the outline of the weeping willow. The brush needs to be fairly dry when you add the bark texture which is created with rough side strokes and varying tones. Change to a small long-haired brush and draw in the willow branches with long, graceful movements which sweep down from the branches to the tapering ends. Add more dark tones and see how the tree springs to life.

Now sketch in the foreground rocks. Using the medium soft brush, outline the rocks. Use heavier, thicker brush strokes on the rocks in front to create a feeling of depth and perspective...

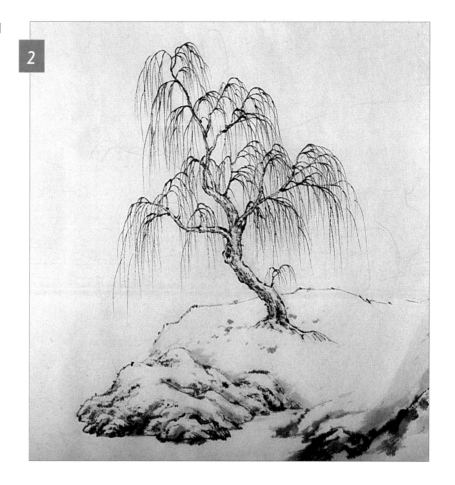

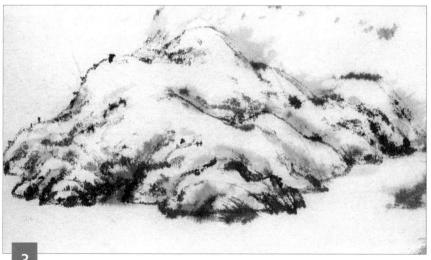

...and wash tone into the crevices to create shadows. Add more dark tones to create grasses, leaving highlights here and there, where the snow is catching the morning light.

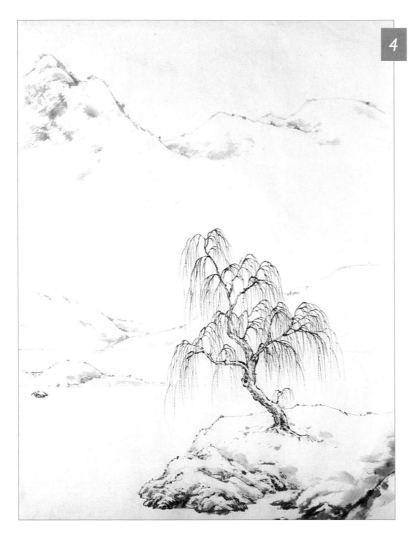

4 Still using the medium brush and black ink, brush in the hills in the middle distance and the far mountains. Weaken the ink, then add shadows. Keep your brushwork loose as you paint. If the lines are heavy and dark, the sense of perspective will be lost. The foreground brushwork should be darker and the strokes will therefore appear more prominent.

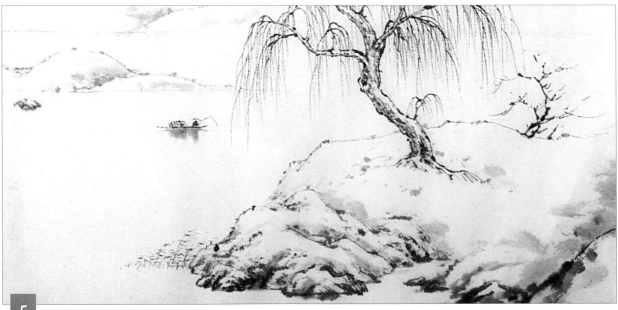

5 With a small, long-haired brush, paint in some grassy spikes to the left of the foreground rocks. Using varying tones, add the small boat, the fisherman and their reflections in the river. Finally, using a darker tone, paint in the trunk and branches of the cherry tree to the right of the willow, to indicate the coming of spring. Leave to dry.

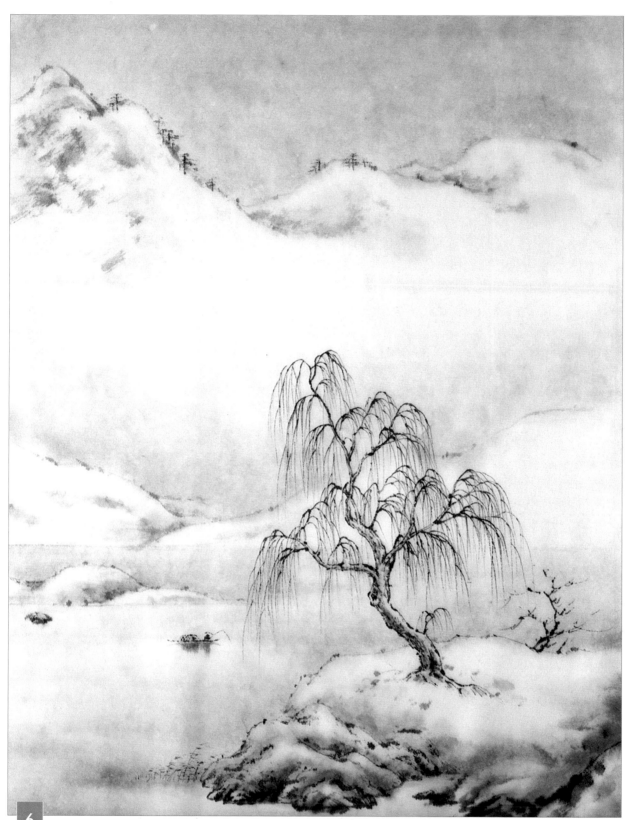

6 Wet all the paper, then using a large soft-haired brush and a weak wash of black ink, work quickly and lay in bands of tone across the lake and over the sky. Lay in touches of this tone over the mountain tops and behind the hills in the middle distance. Making sure there are no hard marks, brush darker tones into the foreground area. Add shadows to the trunk of the willow tree. Leave to dry.

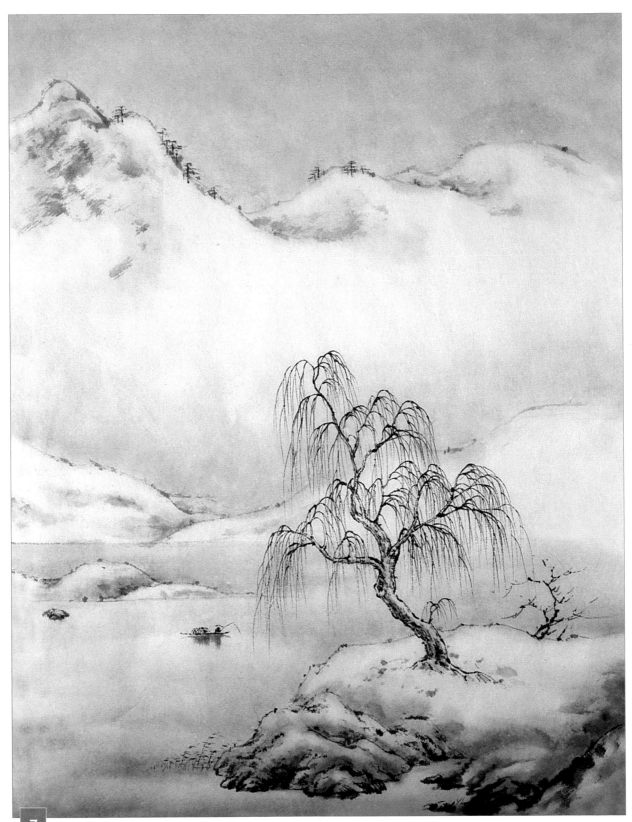

7 The tones will dry lighter as shown here. This tonal background will form the background for the colour that can now be added. It will enhance the feeling of depth, and give a subtle feeling of light and space. The overlaying of colour will bring the painting to life, and highlight selected areas.

8 Wet the whole surface of the paper again, mix blue and turquoise on the palette, then wash the colour over the sky. Also brush this colour on to the mountain top with horizontal flowing strokes.

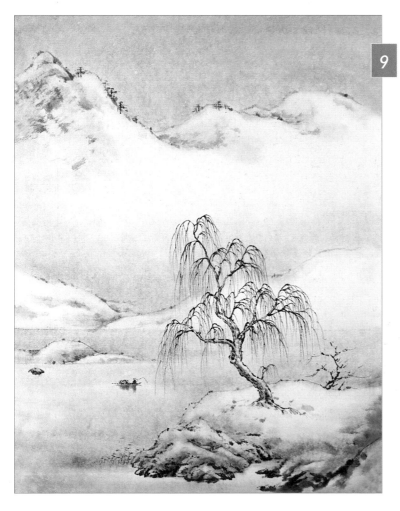

9 Using the same blue and turquoise mix, work down the paper, adding colour behind the hills in the middle distance, across the lake and over the foreground rocks.

65

Mix peony red and zinc white on the palette. Using the medium soft brush paint in the blossom on the cherry tree. Do not try to paint each flower; use dabbing movements to give an all-over impression of blossom. Add highlights using zinc white.

10

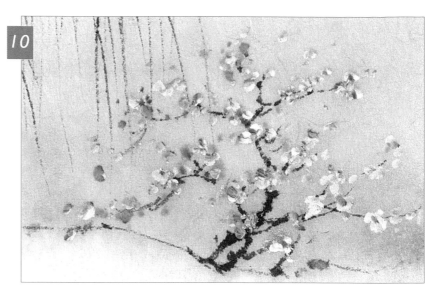

11

Load the small long-haired brush with light brown, then brush the colour into the boat, the fisherman and the reflections. Vary the tones to indicate shadows. Finally, mount the painting on raw Xuan paper as shown on pages 92–94.

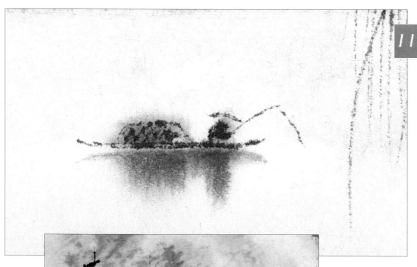

I have added my chosen inscription and my name seal. The characters relate to the subject: spring river with late winter snow.

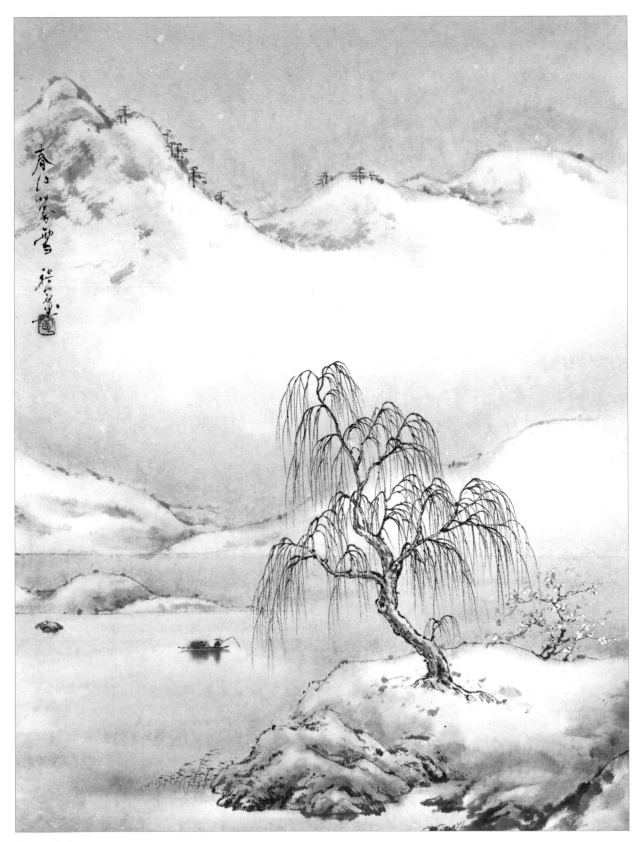

The finished painting

COCKEREL

The cockerel is a popular and inspirational subject in Chinese art. This beautiful male bird, with its impressive crown and beautiful shape, has five virtues: his feet are adorned by spurs which are indicative of a brave warrior, his sharp claws portray a fighting spirit; he is faithful, always keeping good time; his distinctive comb is symbolic of the scholar; he is loyal and kind, always calling for his friends when he finds food.

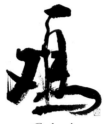

Cockerel

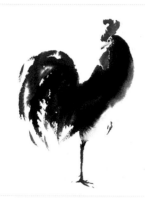

I find the cockerel a very interesting subject to paint. The beautiful lines of the body and the distinctive crown create a dramatic challenge to the artist. The head is painted with a small brush, then the body and wonderfully expressive tail feathers are captured with a few vibrant brush strokes.

MATERIALS

Rough watercolour paper 300gsm (140lb), 155 x 255mm (8 x 5in)
Small long-haired brush
Medium stiff brush
Large soft brush
Black ink
Gouache: cerulean blue, yellow ochre and brilliant red gouache

1 Paint the beak and eye with black ink using the small brush.

2 Using the same brush and brilliant red, add the cox-comb and wattle.

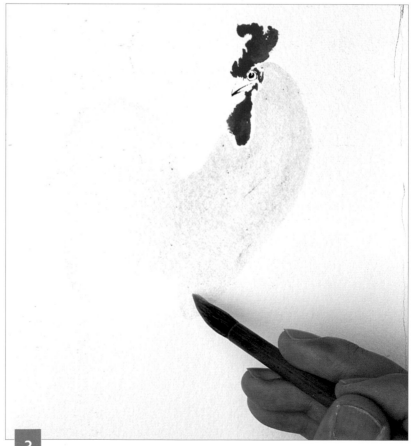

3 Mix a weak wash of cerulean blue. Using the large brush paint in the body and the tail feathers.

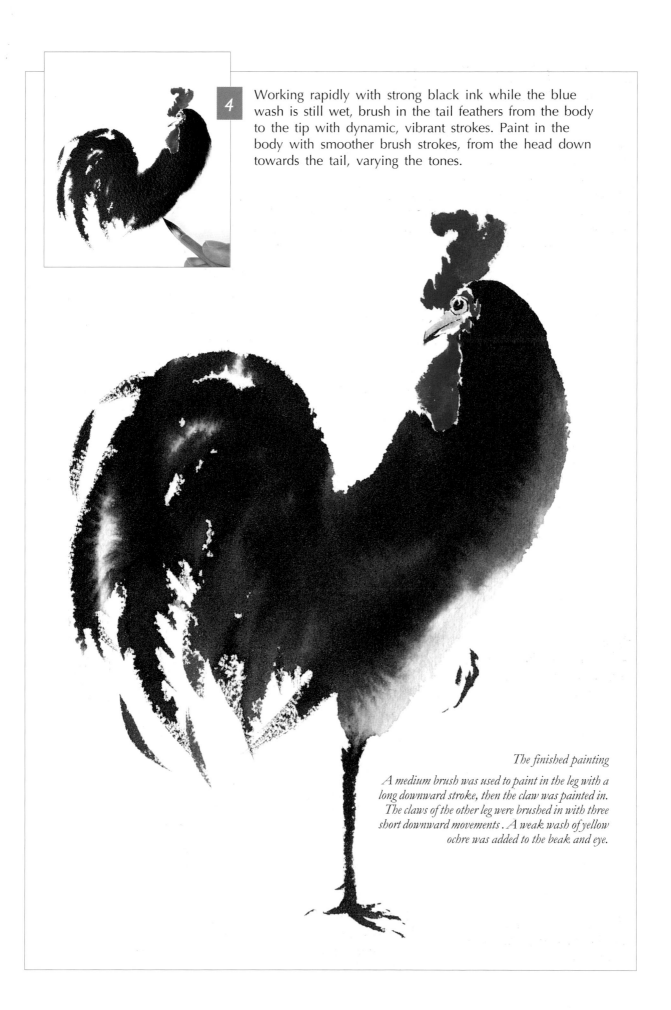

4 Working rapidly with strong black ink while the blue wash is still wet, brush in the tail feathers from the body to the tip with dynamic, vibrant strokes. Paint in the body with smoother brush strokes, from the head down towards the tail, varying the tones.

The finished painting

A medium brush was used to paint in the leg with a long downward stroke, then the claw was painted in. The claws of the other leg were brushed in with three short downward movements. A weak wash of yellow ochre was added to the beak and eye.

SPARROW

Sparrows, with their strong, graceful wings, are another popular subject. These beautiful birds, which represent sensuality in Chinese art, remind me of my childhood home. Their joyful presence is a source of happiness and I love painting them.

Sparrow

When sparrows are included in flower paintings they add grace and movement, as in the painting opposite. The principles of painting one sparrow can be applied to many, so follow the steps below, but also study your subject. It is important that you to understand its anatomy and the way it moves.

MATERIALS

Raw Xuan paper
Medium soft brush
Fine brush
Black ink
Chinese watercolours: orange, brown

1 Wet the medium brush first; load it with orange, then brown. Place the brush on the paper and push the bristles down...

2 ...then lift off to create the body. Add two strokes on either side for the wings in the same way. Then add another stroke for the head.

3 Using a fine brush and black ink brush in the eye and beak.

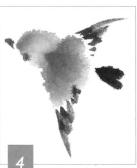

4 Brush in the flight feathers with a series of small strokes. Add two strokes for the tail feathers.

5 Using the tip of the brush, a weak wash of black ink and fine lines, indicate the underside of the head and the body. Add a short stroke to link the tail feathers to the body. Finally, add a few speckles.

HAPPY SPARROWS

Chinese paintings are normally not a reflection of true reality, but are an interpretation of the artist's ideas, although the artist must have a deep understanding of the subject. Here, small and medium brushes are used on card with black ink, Chinese watercolours and white gouache. The sparrows' top feathers are painted using earth colours, and their breasts are painted with a mix of white gouache and a touch of black ink. The cherry tree branches are brushed in with a medium stiff brush, black ink and brown. The blossom is painted in using white gouache with a touch of pink.

Size of painting:
160 x 305mm
(6 1/2 x 12 in)

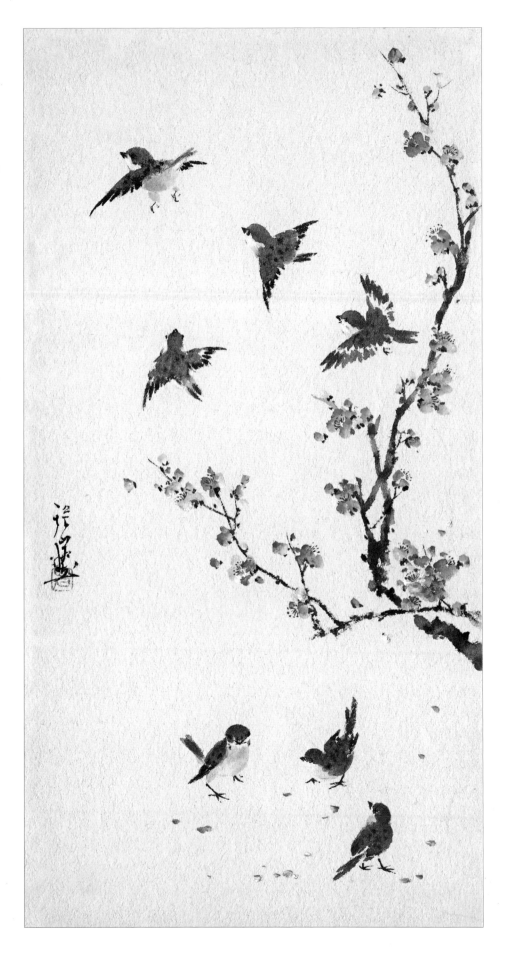

SWALLOW

Swallows migrate, but they always return to their nests every year so they are regarded as a symbol of Spring. It is a good omen if they choose to nest in your home. They bring hope, fresh beginnings, success and prosperity.

Swallow

A few simple strokes can give a sense of movement, joy and freedom. Here, the simple techniques can be applied in different ways. Once you have learnt the basic strokes, practise painting the swallow in graceful flight, as shown opposite.

MATERIALS

Raw Xuan paper
Medium soft brush
Fine brush
Black ink
Chinese watercolours: red

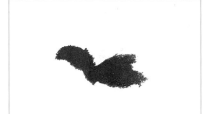

1 Using black ink and the medium brush, paint in three small linked strokes for the body and the base of the wings.

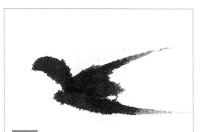

2 Add the head with one downwards stroke and link it to the body.

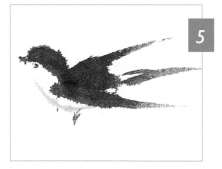

3 Add the long flight feathers to the base of the wings, moving the brush from the body outwards.

4 Make two long tapered strokes for the tail and use the tip of the brush to add the eye and the beak.

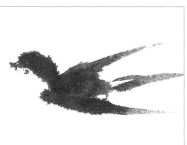

5 Use a weak wash of black ink and the fine brush to paint in the underside of the body. Make two marks for the feet.

The finished painting
A dab of red paint was added to the bird's throat to create the distinctive marking.

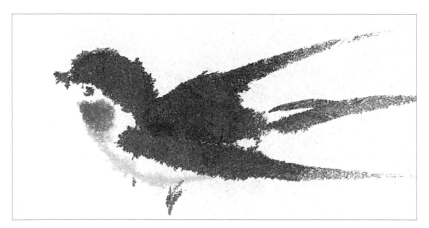

SPRING BREEZE

Swallows are generally painted with the willow in Chinese art. These beautiful birds and the tree are painted on card using a soft medium brush, black ink, Chinese watercolours and white gouache. A lot of space has been left in the composition to create a feeling of freedom and movement. The trailing willow branches sweep down towards the right of the picture and the birds are flying towards the tree top in perfect harmony.

Size of painting: 160 x 305mm
(6 1/2 x 12 in)

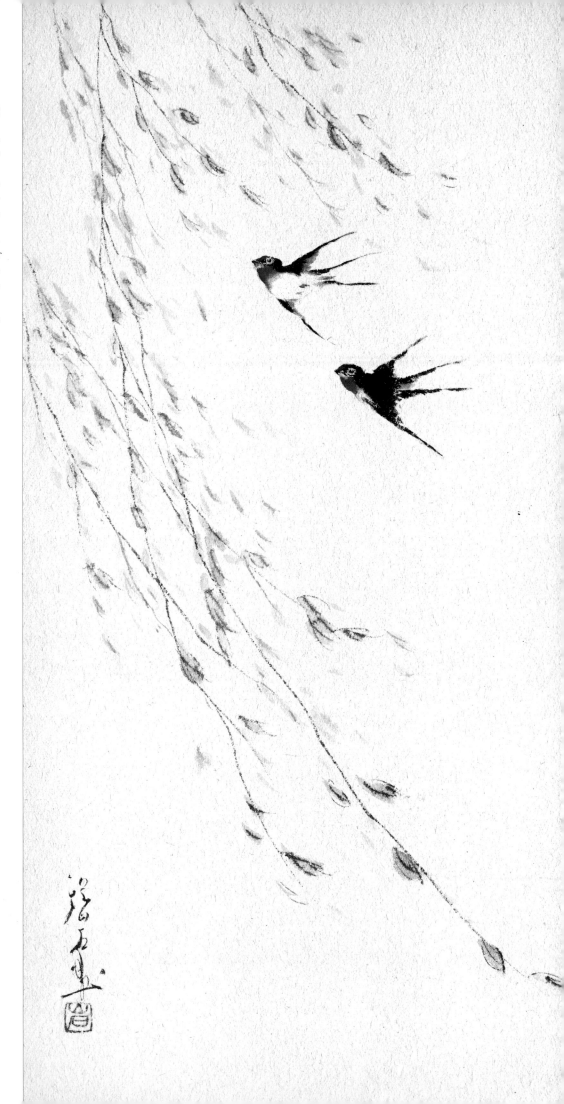

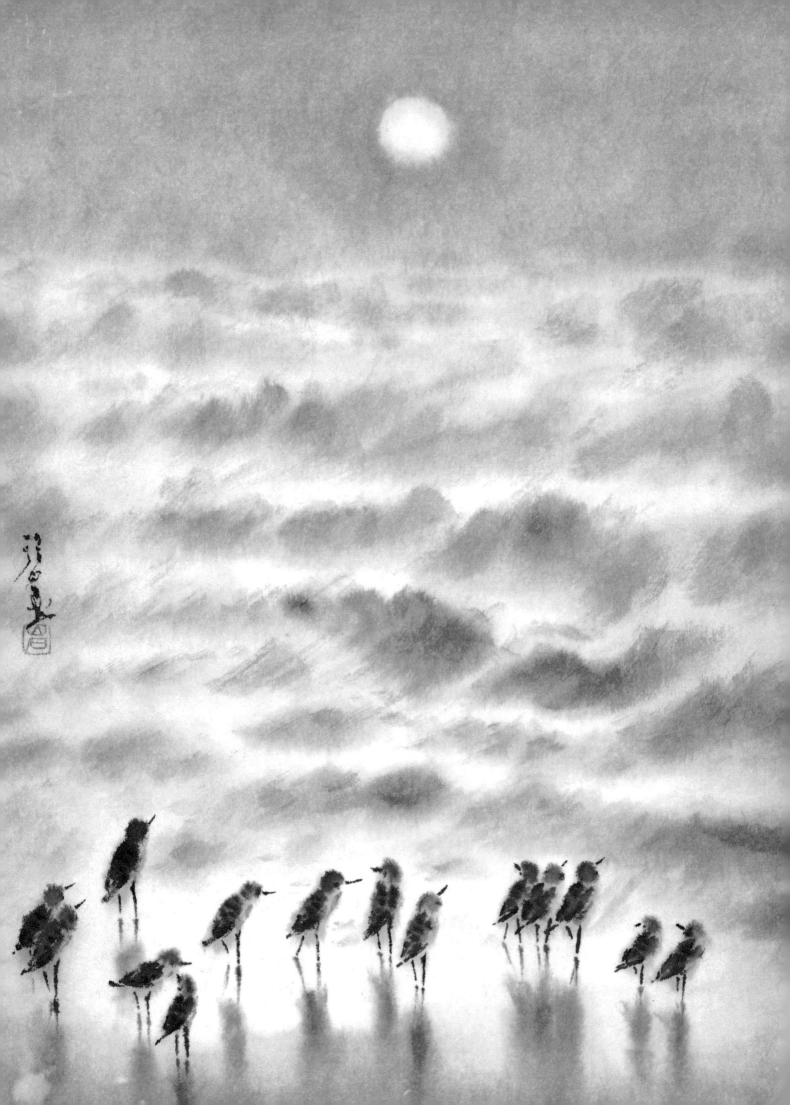

Opposite
MOON RISE

Shore birds gather on a moonlit shore while the waves dance under the night sky. Small and medium brushes are used on raw Xuan paper to create this atmospheric scene. Water is applied over the surface of the paper first, leaving the round moon shape. Diluted grey ink tones are added. When the painting is dry, water is brushed on to the surface again, then blue and darker grey tones are added. The birds are painted with earth colours and black ink. Bird reflections are not traditionally painted, but here I have added soft reflections which merge into the wet sand.

Size of painting: 215 x 298mm (8½ x 11¾ in)

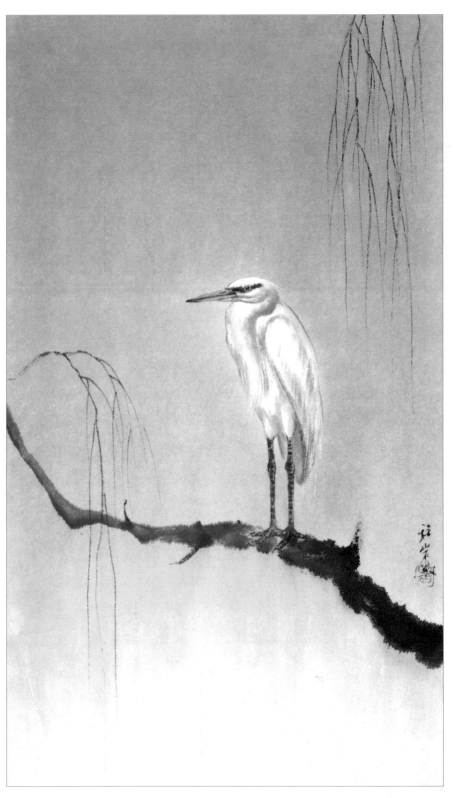

SOLITUDE

A heron looks out over a misty lake in silent contemplation. A medium soft-haired brush and a small long-haired brush are used on raw Xuan paper to create this atmospheric painting. The colours are the same as those used opposite. The bird is painted first using the medium brush, then the details added with the small brush. The branch is painted next with a few strokes of the medium brush, then the background wash is added. The few hanging willow branches are painted with a long stiff brush. They give a sense of space and the mood is enhanced by the posture of the heron as it waits alone in the night.

Size of painting: 165 x 310mm (6½ x 12¼in)

HORSE

Horses are majestic animals, embodying strength and power. They are seen as emblems of perseverance and speed in China and they symbolise good fortune and success. The horse in this demonstration embodies freedom. It has escaped from its earthly ties and is galloping joyfully through the sky, far away from its labours.

Horse

I have always loved horses and throughout the years have taken every opportunity to study them. The ideas and emotions of the artist can be transferred into any subject. Here, the joy of freedom is seen clearly in its graceful, heavenly flight.

MATERIALS

480 x 350mm (19 x 13¾in) sheet of Mulberry paper
Large soft brush
Medium brush
Black ink

Using quick, bold strokes, and the large brush, start painting the outlines of the neck and body in black ink.

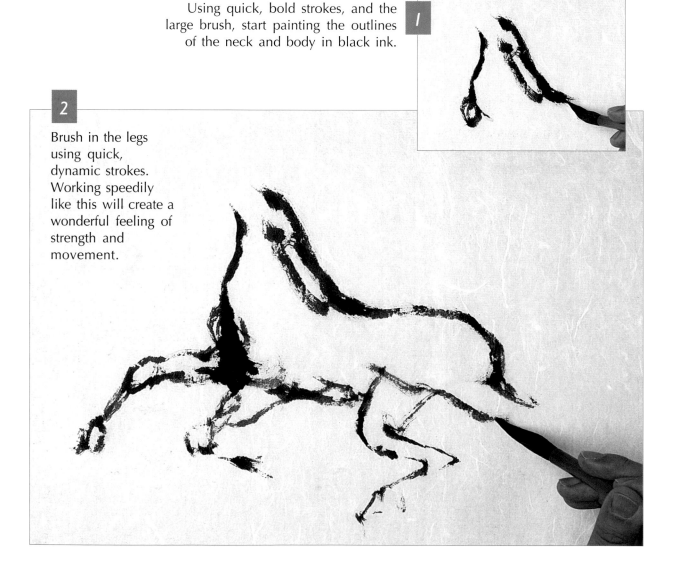

2

Brush in the legs using quick, dynamic strokes. Working speedily like this will create a wonderful feeling of strength and movement.

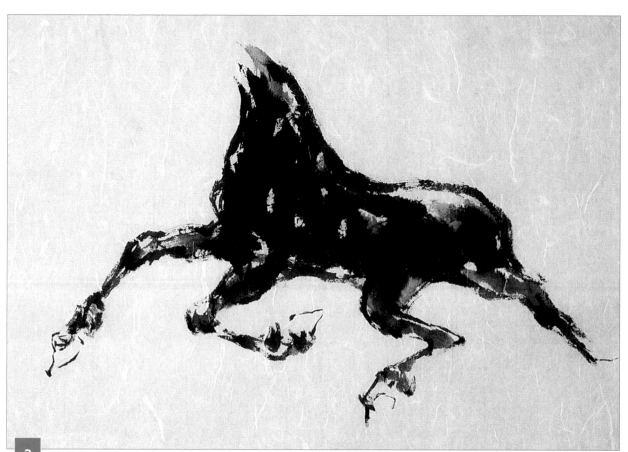

3 Now brush in the body varying the size and angle of the brush strokes and following the contours of the horse's body. Think ahead before you start to paint and leave white space for lighter areas and highlights. The white of the paper creates the highlights and you can add mid-grey areas with a weaker wash.

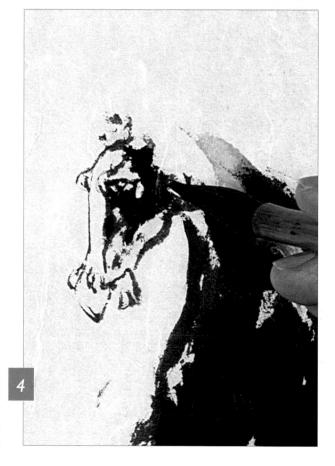

Using the tip of the brush, paint fine strokes to outline the head and place the features. Brush in the dark tones, varying them slightly and following the contours of the head. **4**

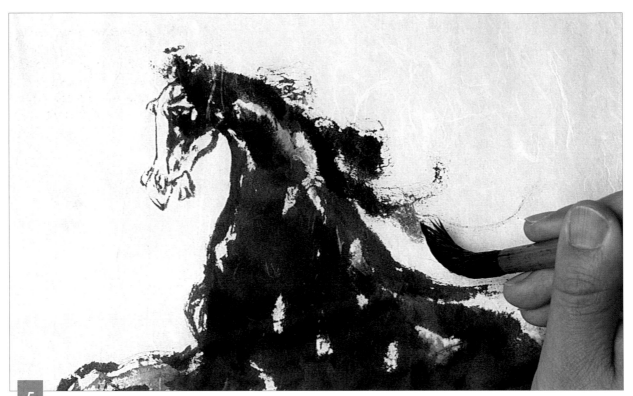

5 Brush in the flying mane using rotating brush strokes, twisting the bristles and pulling the brush down at a slight angle away from the body. This will create a feeling of movement.

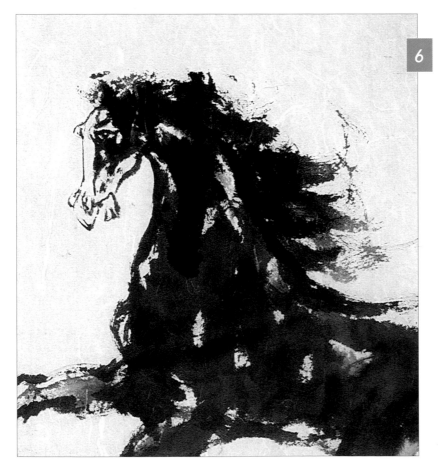

6 Add darker tones to the mane, head and neck.

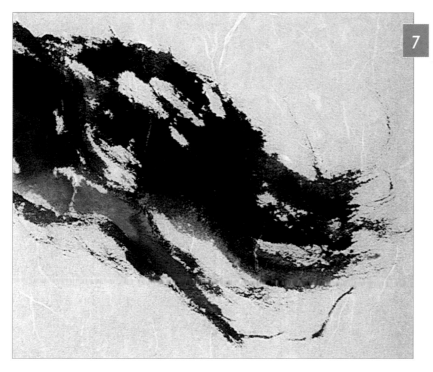

7 With brisk, downward strokes, brush in the tail. Work fairly quickly and taper the strokes off at the base. Leave some white areas. This will help create a feeling of movement.

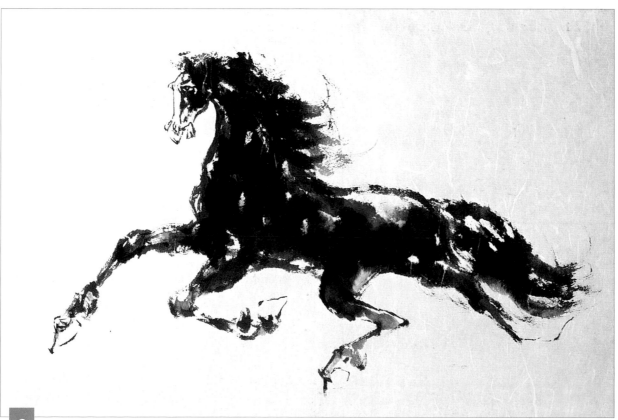

8 Finally, strengthen and darken tones all over the body to develop the three dimensional shapes of the muscles and limbs. Add your calligraphy using black ink and a medium brush, then mount the painting on Mulberry paper as shown on pages 92–94.

Overleaf
The finished painting

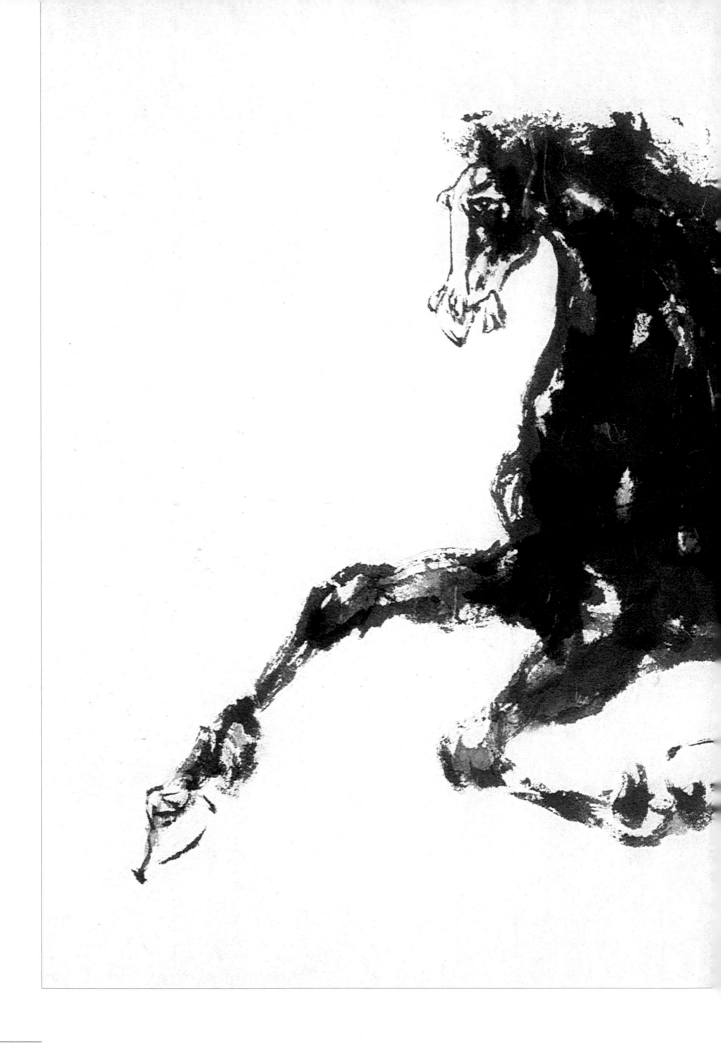

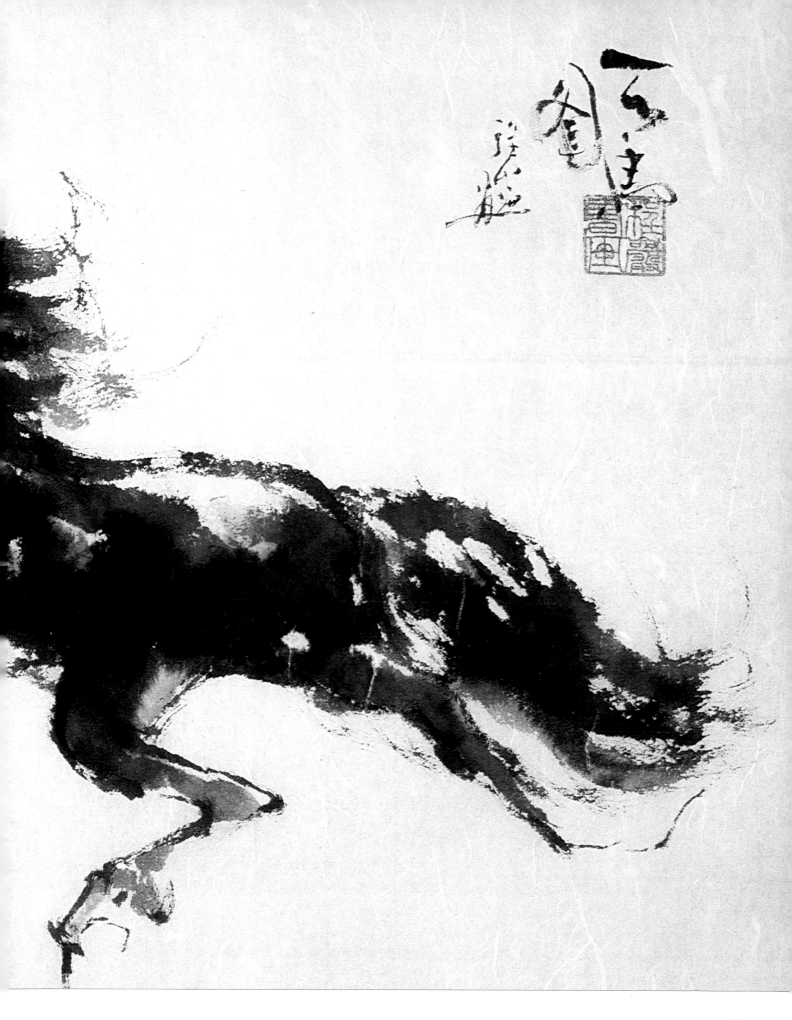

FOX

This is an unusual subject and not seen often in traditional Chinese art, but I find foxes mysterious and beautiful. These crafty, inquisitive animals are regarded as an omen of wealth. They are also thought to have supernatural powers which enable them to transform themselves into human form.

Fox

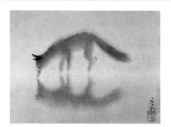

The bright colour and timid nature of these animals makes me want to paint them. Interesting fur effects can be created on Xuan paper using wash techniques, as shown in this demonstration. The fox on a lake shore in the moonlight has been painted from memory.

MATERIALS

285 x 140mm (11¼ x 5½in) Xuan paper
Small stiff-haired brush
Medium soft-haired brush
Black ink
Chinese watercolours: earth brown, pale blue
Spray bottle

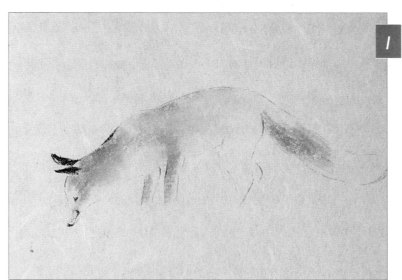

1 Use the small brush and black ink to indicate the ears and features, then use the medium brush and a weak wash to block in the head, body and tail.

2 Strengthen the tones building up the light and dark areas.

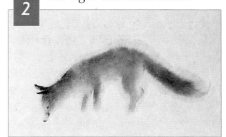

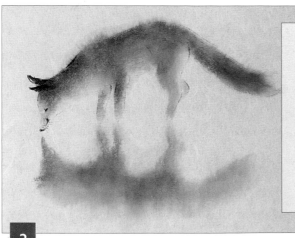

3 Add the soft reflection, mirroring the fox's image in slightly lighter tones.

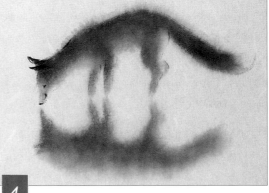

4 Brush an earth brown wash over the whole body and the reflected image, varying the tones.

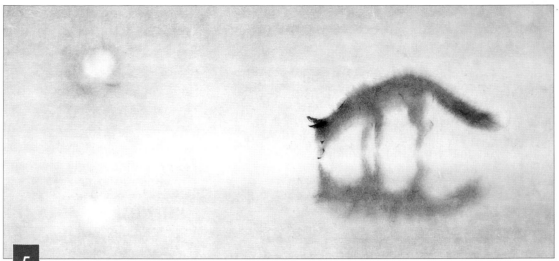

5 Spray water over the paper. Work wet-into-wet with the medium brush and paint round the moon using a weak wash of black ink. Draw ever increasing circles, softening the outer edges, then lay a wash over the rest of the sky. Using even weaker washes, create a mirror image of the moon in the water. Leave to dry.

Respray the paper with water, then brush a weak blue wash over the sky with horizontal strokes, starting at the top and reducing the tone as you work downwards to the horizon.

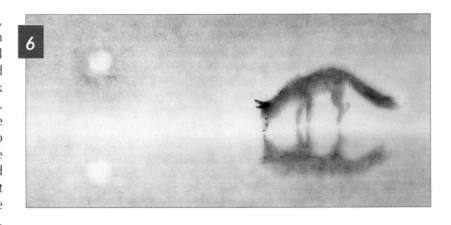

Then, working from the bottom, apply a blue wash to the water. Finally, add the calligraphy with black ink and a medium brush, and mount the painting on mulberry tree paper, see pages 92–94.

The finished painting

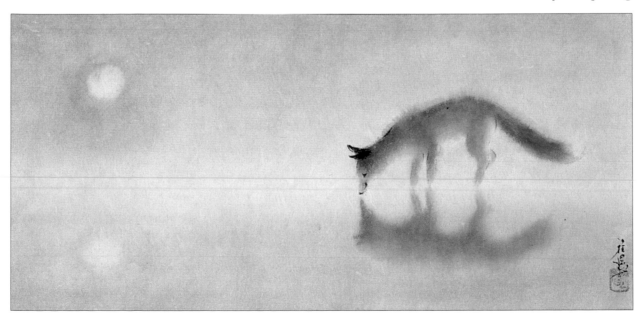

Now I am going to mount the painting. It is traditional to mount any picture that is painted on Xuan paper, or any lightweight paper, using the same type of paper. This will strengthen it and also enhance the colours. The traditional way of working is to use a red working surface, because the strong colour can be seen through the painting and any errors will show up clearly. Make absolutely sure that there is no loose paint anywhere. If there is, fix it with alum water. When the painting is dry, place it face down on the table, then use the water sprayer to wet the back.

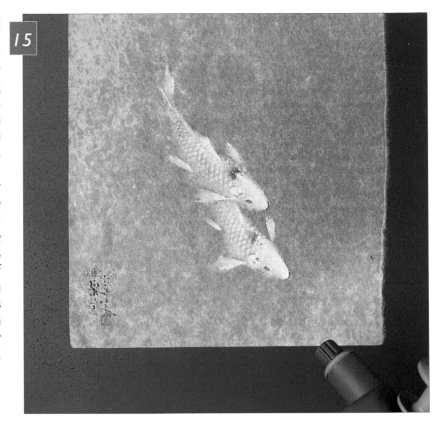

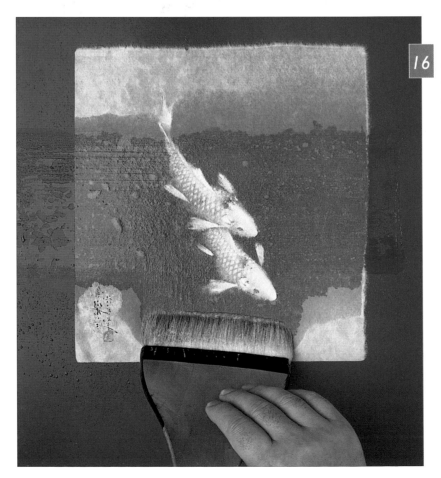

Use a wide flat brush to apply flour paste to the back of the painting, working from the centre out towards each side. Carefully smooth away any air bubbles or creases.

.Cut a sheet of raw Xuan paper, larger than the painting, to allow for a substantial overlap on all four sides. Roll up this sheet, then align it over one side of the wet painting with an overlap at that side, the top and bottom.

17

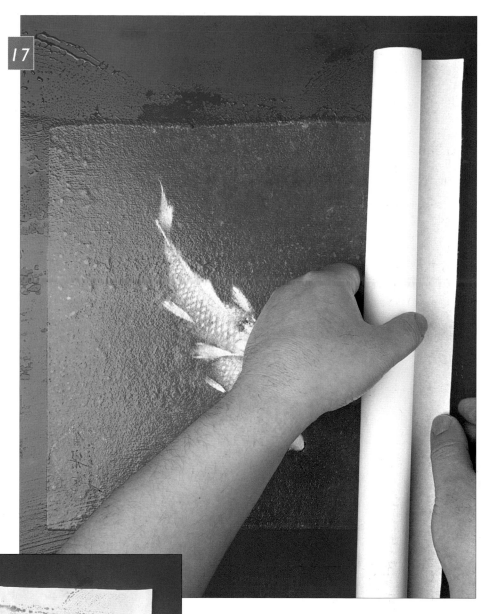

18 Gradually unroll the dry Xuan paper across the wet painting, smoothing it down with your hand, or a dry, flat brush.

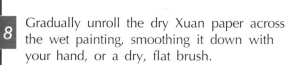

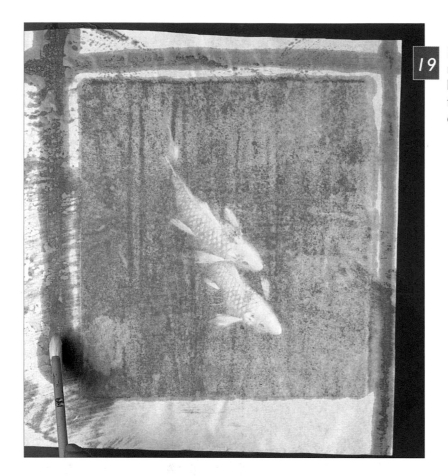

19 Leaving a dry gap round the painted area, brush narrow bands of flour paste round the outer edges.

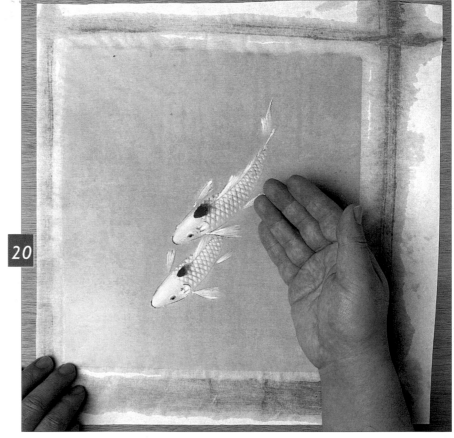

Carefully lift the backing paper and painting off 20 the work surface, stick it on a smooth flat surface, stretching it so that it is very flat. Leave until the paper is completely dry, then remove the painting by cutting between the outer edge of the painting and the strips of paste.

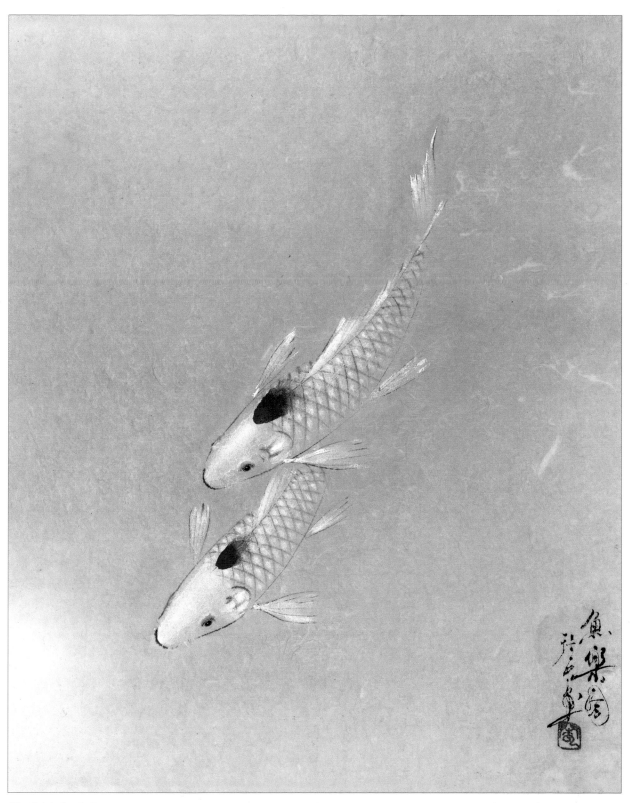

The finished painting
Size: 255 x 275mm (10 x 10½in)

INDEX